WINGS OVER WATER

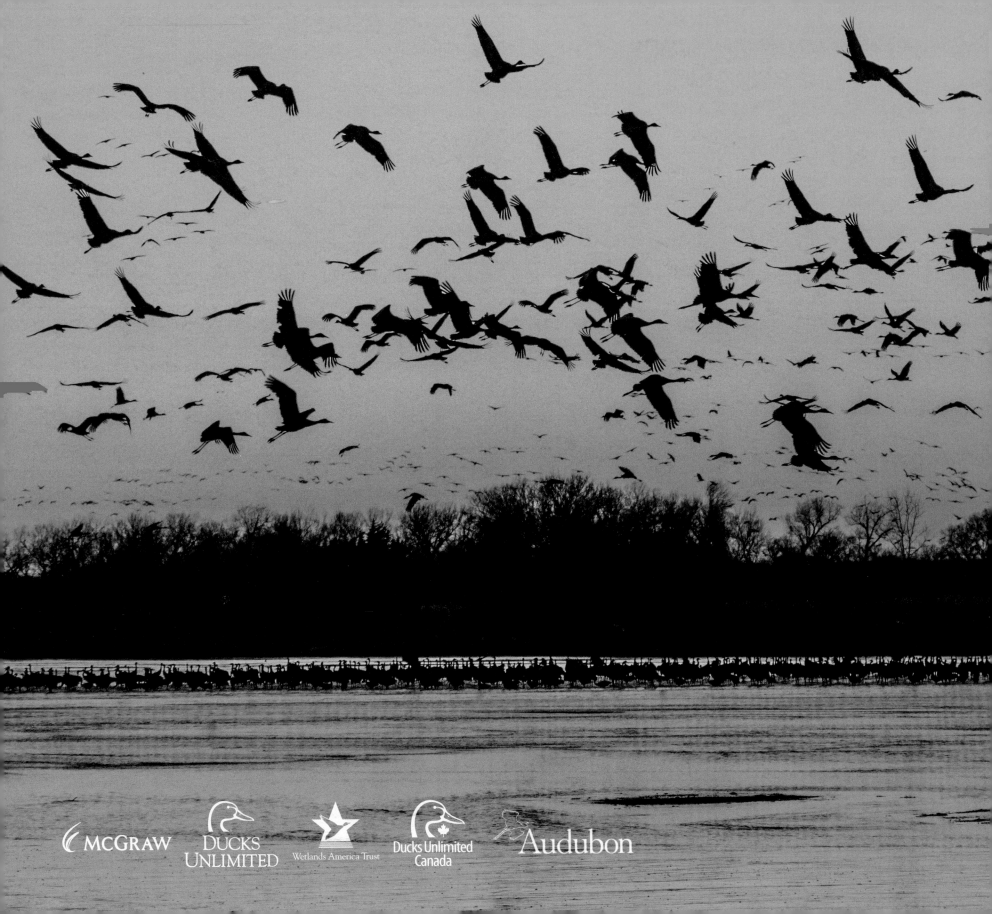

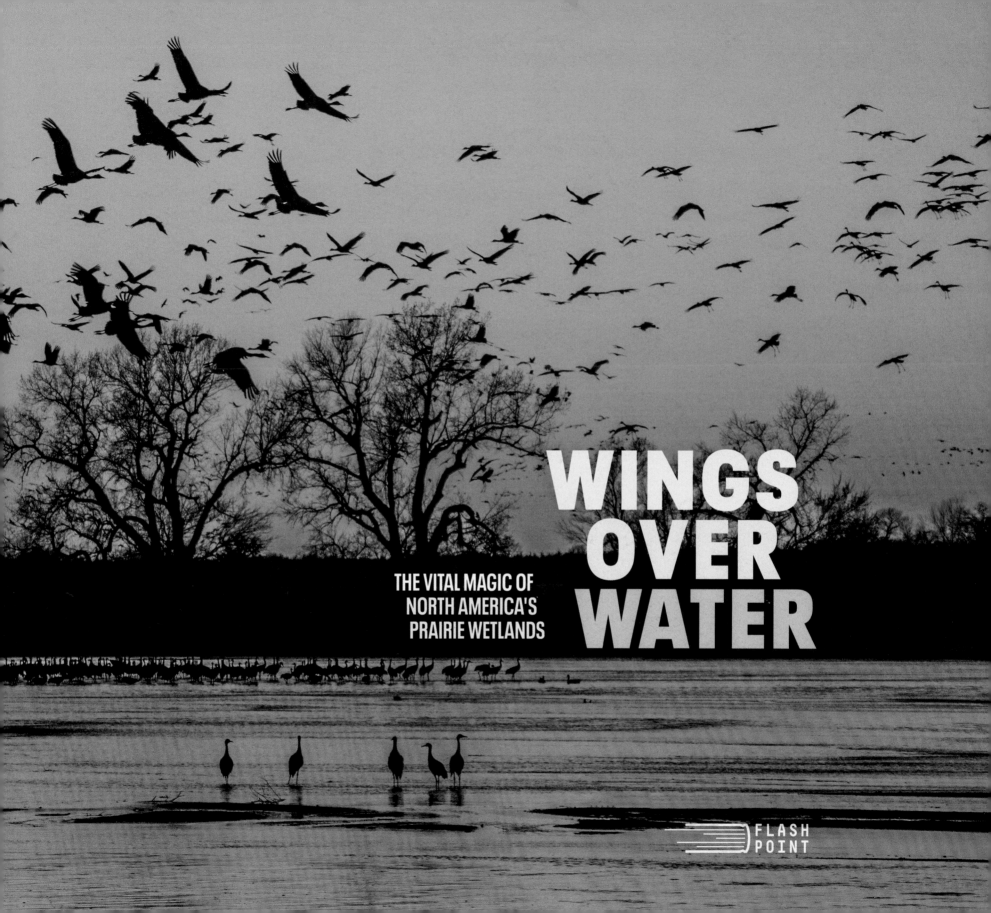

WINGS OVER WATER

THE VITAL MAGIC OF NORTH AMERICA'S PRAIRIE WETLANDS

FLASH POINT

Published by Flashpoint™ Books, Seattle
www.flashpointbooks.com

Produced by Girl Friday Productions

Cover and interior design: Zach Hooker
Photo research: Micah Schmidt
Development & editorial: Katherine Richards
Production editorial: Laura Dailey

ISBN (hardcover): 978-1-954854-55-0
ISBN (e-book): 978-1-954854-56-7

Library of Congress Control Number: 2021923821

First edition

Printed in Canada

Contents

Edited by Kerry Luft

Principal photography by Gary Kramer

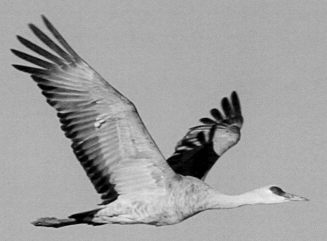

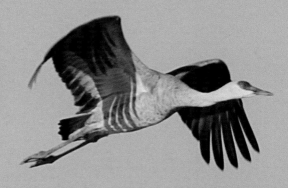

Foreword

By **Michael Keaton**

Academy Award–nominated actor Michael Keaton, the narrator of Wings Over Water 3D, *is a passionate conservationist dedicated to the preservation of habitats that sustain wildlife in the Great Plains and beyond.*

When I was a boy in Pennsylvania, I loved being outside. Summer, winter, spring, or fall, I found adventure in the outdoors and marveled at its gifts and miracles and wondered about its mysteries.

Why did the seasons change? Why did animals hide during the day and come out at dusk? And where did the ducks, geese, and other birds go when winter waned and spring was around the corner? The great vees of migrating waterfowl told me they were headed north, but where?

That final question can be answered simply: they were going home.

In the case of many birds, home is the prairie wetlands of North America, more than 300,000 square miles on the Great Plains. As the glaciers retreated 10,000 years ago, they left behind this landscape of rich grasslands and shallow basins, a paradise for birds. It's home to avocets and phalaropes, pelicans and sparrows, bobolinks and warblers—more than 150 species in all, including many of the ducks and geese I saw as a boy.

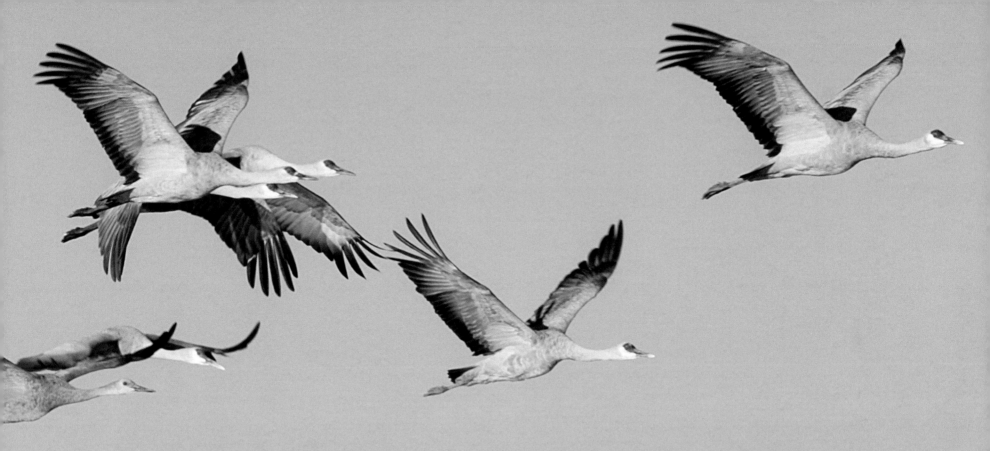

It's estimated that more than half of the continent's waterfowl use the prairie wetlands for breeding, including iconic ducks like the mallard and canvasback. Others, such as snow geese and Canada geese, stop over on their migration to their breeding grounds farther north, resting and taking on fuel for the flights ahead.

The journeys these birds take to return home each spring can only be described as heroic. Imagine a tiny songbird, weighing little more than a page or two in this book, crossing the Gulf of Mexico and then the continental United States. That's just one of the migratory miracles that end in the prairie wetlands; there are scores more.

You may never have heard of this ecosystem, though its biodiversity rivals any on Earth. It benefits humankind as well, storing excess water and filtering it, mitigating the potential for downstream flooding, and recharging the aquifers that allow farmers to harvest the grain that feeds millions of people worldwide.

My friends in conservation say that the prairies are North America's Amazon, and I think they're right.

While wonderful, diverse ecosystems such as the Amazon and Everglades have powerful allies fighting to protect them, the prairie wetlands have been championed only by a small but devoted group of conservationists—mostly waterfowl hunters and other bird lovers. Their efforts have protected many thousands of acres, yet since westward expansion reached the prairies in the 1800s, more than half of the prairie wetlands have disappeared.

When I learned about the plans to create an IMAX 3D movie calling attention to the prairies and their birds, I knew I wanted to help. After all, I know something about birds.

Narrating the film *Wings Over Water* was an honor, and so is writing the foreword to this companion book. Watching the film and reading the book have brought me back to my boyhood, renewed my love for the outdoors, and raised my hopes that future generations of children will have the opportunity to marvel over North America's magnificent migrations and will know where the birds go:

Home.

Sandhill cranes (*Grus canadensis*) in flight

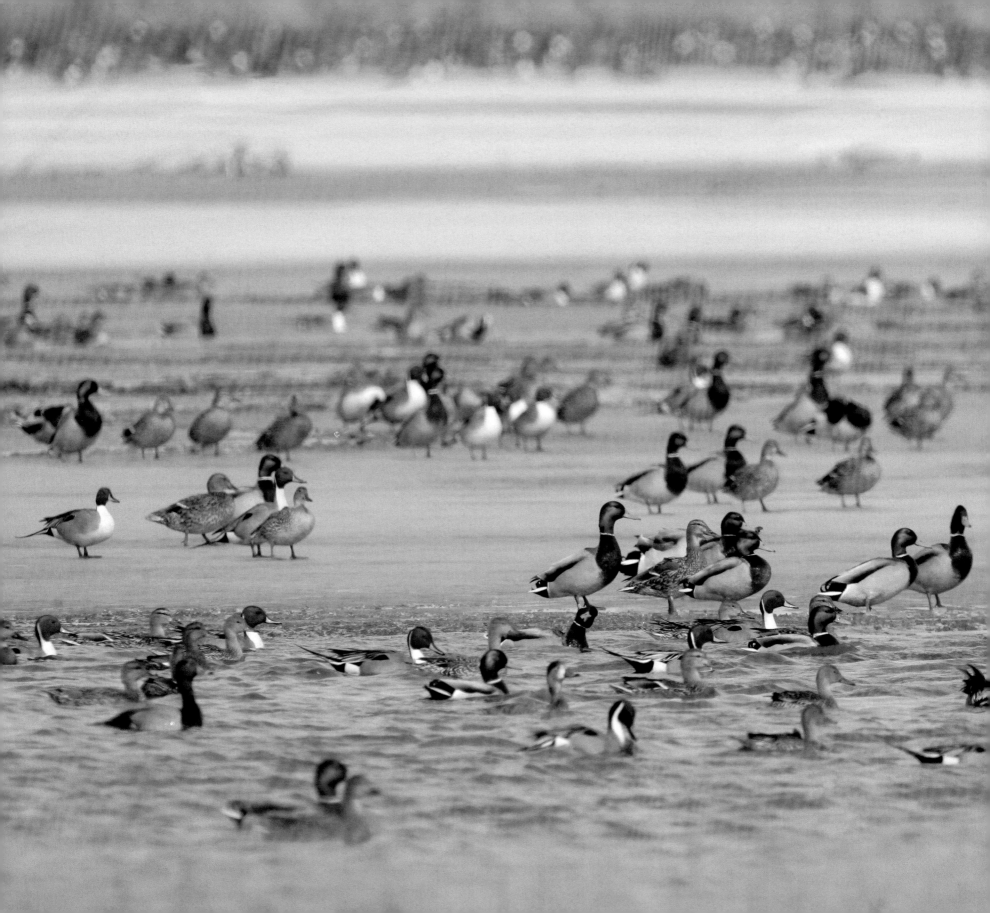

A flock of mallards (*Anas platyrhynchos*) share the water with pintails (*Anas acuta*) and redheads (*Aythya americana*). Mallards and pintails are dabbling ducks that mostly eat what's near the surface of the water, while redheads find much of their food farther beneath the water's surface.

9

Saving North America's Amazon

By **Charles S. Potter, Jr., Max McGraw Wildlife Foundation, Executive Producer**

Charles S. Potter, Jr., is president and CEO of the Max McGraw Wildlife Foundation in Dundee, Illinois, and a lifelong conservationist and advocate for waterfowl.

magine North America's prairies at the dawn of recorded history: more than 100 million acres of grasslands dotted by untold wetlands carved by retreating glaciers, an ecologically rich region to rival the Amazon or the Serengeti.

This rolling landscape nurtured billions of birds, including waterfowl, songbirds, shorebirds, and cranes in the greatest concentrations ever known to humans. The great flocks blackened the horizon as they arrived each spring to breed, and again each fall as they flew south with the young of the year, an annual ritual that has lasted for millennia.

The prairie wetlands stretched from modern-day Iowa and Minnesota, through the Dakotas and Montana, and across what would become three Canadian provinces: Alberta, Manitoba, and Saskatchewan. Their vast ecological significance for birds and other species remains unequaled in North America. Some 50 million people rely on this ecosystem for clean water.

Only remnants of this immense landscape remain, and they are slowly disappearing despite decades of noble and dedicated work by conservationists in the public and private sectors, especially the US Fish and Wildlife Service, the Canadian Wildlife Service, Ducks Unlimited, the National Audubon Society, Delta Waterfowl, and The Nature Conservancy. Few are aware of this looming catastrophe, for despite their significance, the prairies are not well known.

This is about to change.

This book and the IMAX 3D movie *Wings Over Water* are aimed at awakening the continent and the world to the need to protect the prairie wetlands, North America's greatest ecological asset. The prairies are key to abundant birds, clean water, and sufficient grasslands to keep our continent healthy. Without them, we face a future of depleted water resources, decreased water quality, ruinous flooding, and a greatly diminished ability to sequester carbon. The implications for the continent's bird populations are even more bleak.

When the prairie landscape is gone, it will be too late for us, and our planet.

To those who do not hunt, the idea that people can respect or love the animals they hunt is contradictory, perhaps even hypocritical.

White-fronted geese (*Anser albifrons*) are named for the white band surrounding their bills.

About the Prairie Wetlands

More than 11,000 years ago, receding glaciers scoured the land that would become known as the Great Plains of North America, leaving behind a vast network of grasslands and small, shallow depressions called prairie potholes. The region spans parts of five states—Montana, North Dakota, South Dakota, Minnesota, and Iowa—and three Canadian provinces—Alberta, Saskatchewan, and Manitoba.

The prairie wetlands are among the most vibrant ecosystems on our planet. More than half of North America's migratory waterfowl nest in the region, and scores of other bird species either nest in or pass through the region on their way to their own breeding grounds farther north.

Though some of these wetlands are permanent, many potholes are seasonal or temporary, relying on snowmelt and precipitation to refill them each spring. Because most of them are small—less than an acre—they often dry up or disappear altogether during droughts. Many thousands of potholes have been drained and their rich soils planted with crops.

Besides their importance to birds and other wildlife, the prairie wetlands provide great benefits to humans. By absorbing and filtering water, they ease flooding and recharge groundwater systems. Their grasslands protect the soil from erosion and mitigate the effects of carbon dioxide in our atmosphere.

Conservation organizations consider the prairie wetlands to be among the world's most threatened habitats and rank them among their leading priorities for protection and restoration.

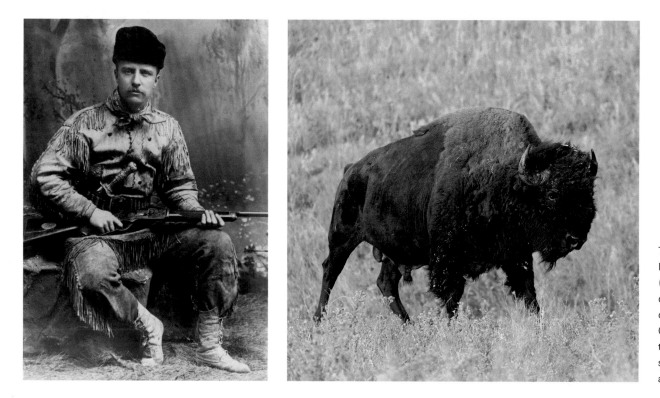

The conservation efforts of President Theodore Roosevelt (left) protected land and wilderness crucial to the survival of the American bison (right). Other hunters were instrumental in bringing back species such as the white-tailed deer and the wild turkey.

Yet conservation in the United States has always been and continues to be driven by hunters, determined to protect the creatures they hunt and their habitats.

Theodore Roosevelt, the greatest conservation president in our history, was a hunter, as were Gifford Pinchot and George Bird Grinnell, his partners in promoting the protection and restoration of the country's wilderness. The legislation they wrote and the practices they and others promoted brought back species that otherwise might be extinct today, including the white-tailed deer, the American bison, and the wild turkey.

Through the years, hunters have been the main sources of funding for conservation, through philanthropy as well as fees and taxes paid for licenses and sporting equipment. Much of that money goes to two programs that are especially important for wetlands: the Federal Duck Stamp program, which has raised more than a billion dollars to protect more than six million acres of waterfowl habitat; and the North American Wetlands Conservation Act, which each year steers millions of dollars to the United States, Mexico, and Canada to protect vital wetlands.

Though hunters have been the primary advocates for wetlands conservation, the wetlands benefit us all, including those who will never set foot in a marsh. And today, hunter numbers are dwindling. There are many reasons for this, but the unspoken side effect is a diminished pool of support for conservation programs, putting many endangered habitats at even greater risk—including the prairie wetlands.

What will we lose if we lose our prairie wetlands?

We will lose untold numbers of birds, from regal canvasback ducks to valiant, tiny warblers, all of which rely on this ecosystem for breeding habitat and the food to fuel them on their fall migrations.

We will lose many of the myriad pleasures associated with those birds, such as the liquid notes of a songbird at the break of day, or the high-flying, raucous skeins of Canada geese heading north as spring begins.

On the left: An American coot (*Fulica americana*) surveys the water.

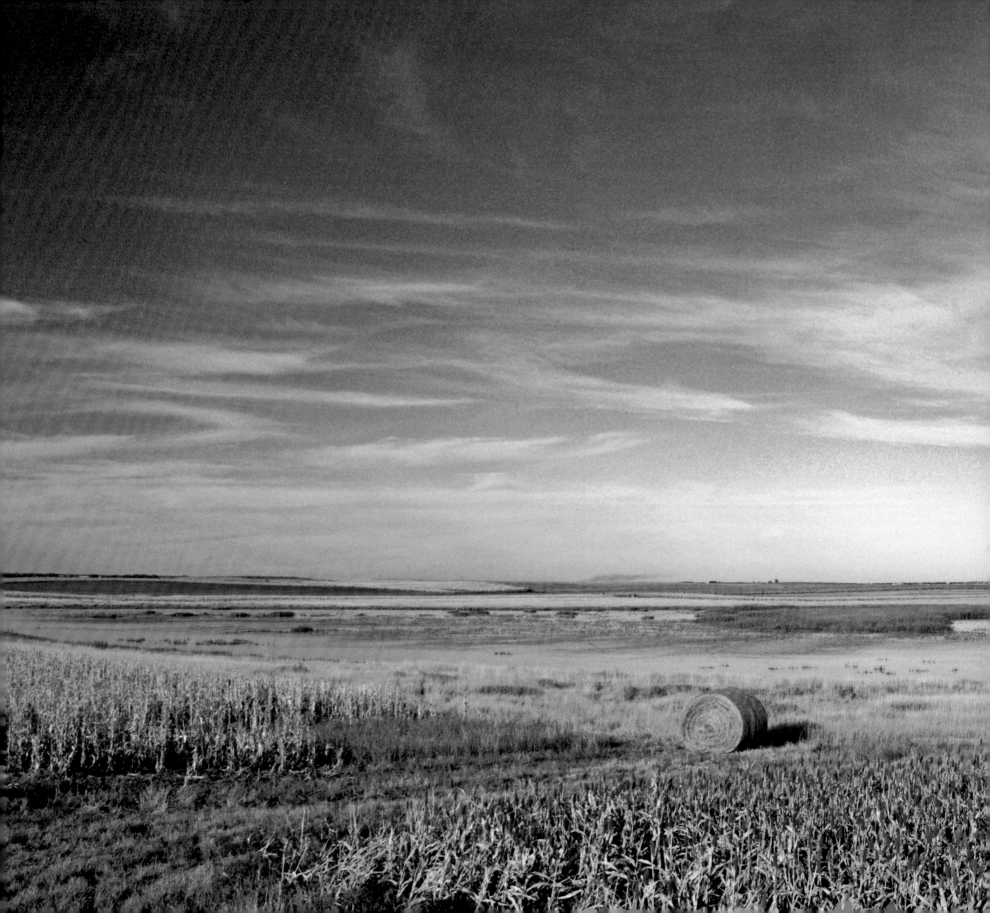

About the Max McGraw Wildlife Foundation ⟨ MCGRAW

The story of *Wings Over Water* begins with Max McGraw. A legendary entrepreneur and founder of the McGraw-Edison Company, he also was a pioneering conservationist inspired by his lifelong friendship with J. N. "Ding" Darling, the founder of the Federal Duck Stamp program, and a later friendship with Aldo Leopold, the father of modern game management.

In the 1930s Mr. McGraw's love of hunting and the outdoors led him to establish a game farm and fish hatchery to try to supplement dwindling natural populations of game birds and fish. This farm, near Chicago in Dundee, Illinois, became one of the first hunting and fishing preserves in the Midwest and the model for scores of others. In addition, Mr. McGraw strongly supported the efforts of nascent conservation organizations such as Ducks Unlimited and the North American Wildlife Foundation, which years later would be renamed the Delta Waterfowl Foundation.

In 1962 Mr. McGraw decided to ensure that the conservation work he began would continue beyond his lifetime, and to that end he established the Max McGraw Wildlife Foundation, a nonprofit entity dedicated to ensuring the future of hunting, fishing, and land management through programs of science, education, demonstration, and communication. Two years later, he died while on a duck hunting trip in Utah.

The Foundation lived on at his old farm, not only as an oasis for outdoor recreation and relaxation but as a research and educational organization inspired by one of Mr. McGraw's favorite sayings: "There is a way to do it—better find it."

Over the next several decades the McGraw staff conducted experiments that produced hardier game birds and fish, introduced hundreds of schoolchildren from nearby Chicago to nature, and began what would become the world's longest ongoing study of urban mammalian predators—namely coyotes. Scores of wildlife students used McGraw as a home base for research projects, up to and including doctoral theses.

In the early twenty-first century, McGraw developed what was to become the premier hunting-awareness program for natural resources students and professionals, who increasingly had no firsthand knowledge of hunting or its role in scientifically sound wildlife management. Conservation Leaders for Tomorrow has since graduated more than 2,600 participants, representing 40 universities and 42 state and federal agencies.

Building on that success, McGraw's leaders began thinking about the ways conservation is financed. Inspired by Mr. McGraw's entrepreneurial spirit and business acumen, the Foundation launched a series of innovative projects designed to promote economic and program efficiency in conservation. Early work included a blueprint for better, more responsive state natural resource agencies, a white paper that presciently offered improvements and enhancements for the federal Land and Water Conservation Fund, and a project that resulted in the only completely new conservation program in the 2018 Farm Bill. Called the Soil Health and Income Protection Program, it was authorized as a pilot program in the prairie states to give landowners greater flexibility in enrolling their lands in conservation programs.

Now entering its seventh decade, McGraw continues working to secure the future of hunting, fishing, and land management through programs of science, education, demonstration, and communication. It is the organizing entity behind *Wings Over Water*.

On the left: The prairie wetlands region of the upper Midwest, clad in gold

On the right: Conservationist Max McGraw fishing

The northern pintail is known for its long, distinct central tail feathers.

We will lose a magical landscape, shaped eons ago by geological forces and still providing the bounty that sustains life for hundreds of species.

We will lose the wetlands' ability to store and filter water, to recharge vast underground aquifers with purified water, to sequester carbon, and to lessen the risk of flooding.

We will lose a part of ourselves.

Wings Over Water **celebrates and** builds on the work of many, including the governments and private sector groups of the United States, Canada, and Mexico, who for 30 years have worked to advance one of the grandest conservation plans in history: the North American Wetlands Conservation Act.

Now it is time for all of us to join this effort and to see the multitude of interest groups that care for birds and clean water come together to help NAWCA achieve its maximum potential. We can save North America's birds and the continent's most important ecological landscape, our prairies.

The millions of people across North America and around the world who will see *Wings Over Water* in IMAX 3D and other formats in the coming years will understand why the prairies matter, and what we stand to lose forever unless we act.

Scientists have reported that more than three billion birds vanished from North America during the past fifty years. Many of these birds relied on the prairies for breeding and sustenance. For the sake of our very existence and quality of life, we must save and renew this region. In doing so, we can bring back one billion birds.

Let us rise to the challenge and not rest until we have succeeded.

A perched yellow warbler (*Dendroica petechia*). Yellow warblers are one of the three species followed in the *Wings Over Water* film.

The film team tries to blend in to capture the shot.

How *Wings* Took Flight

In 2016, the Max McGraw Wildlife Foundation began an unprecedented review of the funds sent to Canada's prairies under the North American Wetlands Conservation Act in hopes of identifying potential improvements to the system, ensuring that it could be held up as a model of effective conservation and efficient government spending. The project team included distinguished conservationists from across the nation, including former leaders of state natural resource agencies or branches of the US Fish and Wildlife Service, scientists, a Pulitzer Prize–winning journalist, and other experts in communications.

After more than two years of research, the team reached an astonishing conclusion: if anything, the significant accomplishments of NAWCA in prairie Canada had been underreported. Its success story could and should have been better told.

At the same time, those wetlands that had not been protected were dwindling at an ever-increasing rate, particularly the temporary and seasonal wetlands that are most important to the continent's birds. Yet aside from a cadre of concerned waterfowl hunters and other bird enthusiasts, few knew of the looming catastrophe.

During a summit of the nation's leading waterfowl conservationists, McGraw presented the team's findings as well as a recommendation that the assembled group drive a communications campaign to increase public awareness of the prairie wetlands and their importance to the world. Hunters all, the members of the group realized that many other people would join them in striving to protect wetlands, if only they knew of their significance.

This realization inspired the partnership that created this book and the film. For more than two years, an award-winning team of filmmakers and a support group made up of many of the continent's most important conservation organizations have worked together to bring you this remarkable story. Only IMAX can capture the majestic migrations of birds and the wonder of life on the birds' ancestral breeding grounds.

Only we can save this precious ecosystem.

The canvasback (*Aythya valisineria*) is a diving duck that often feeds on underwater plants.

Two young sandhill crane chicks, called colts, stay near their parents.

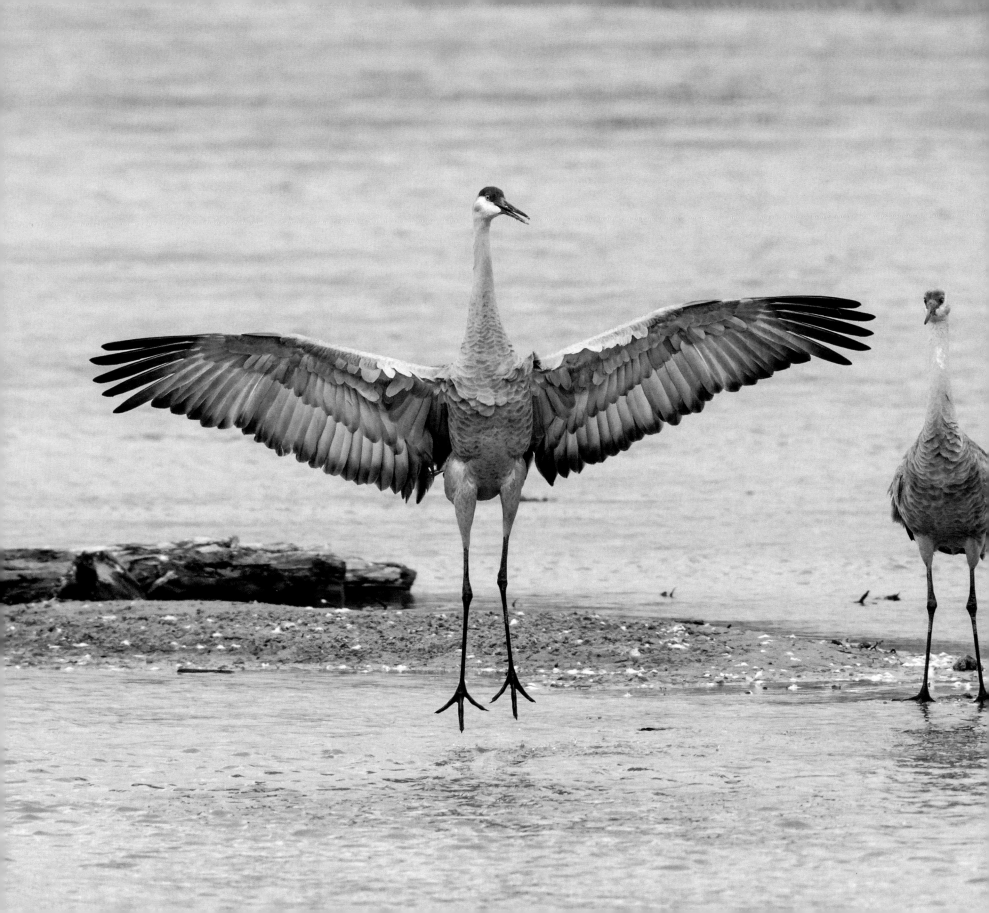

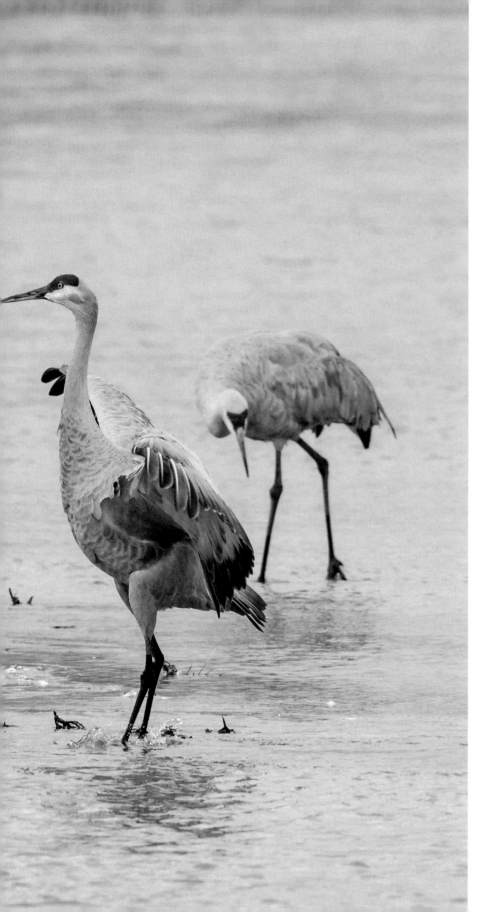

Sandhill cranes gathered at the Platte River, a major stopover on their migration

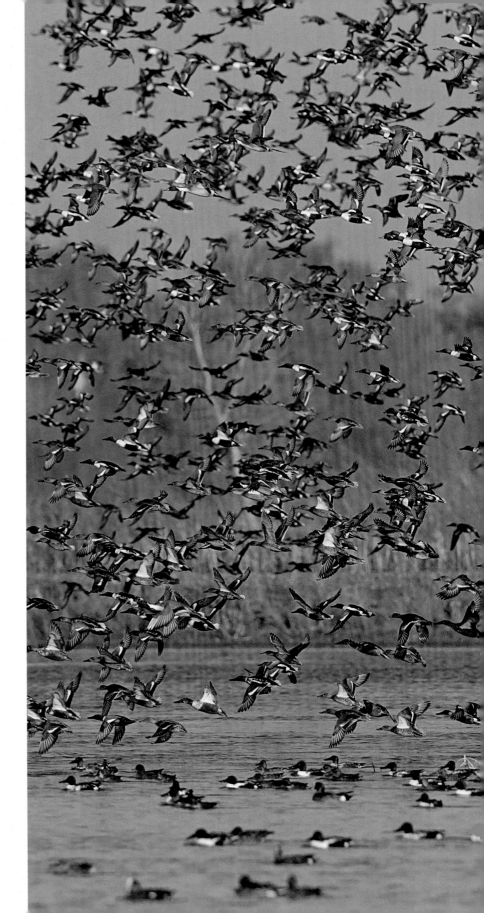

24 | Northern pintails and American wigeons (*Mareca americana*) fill the air.

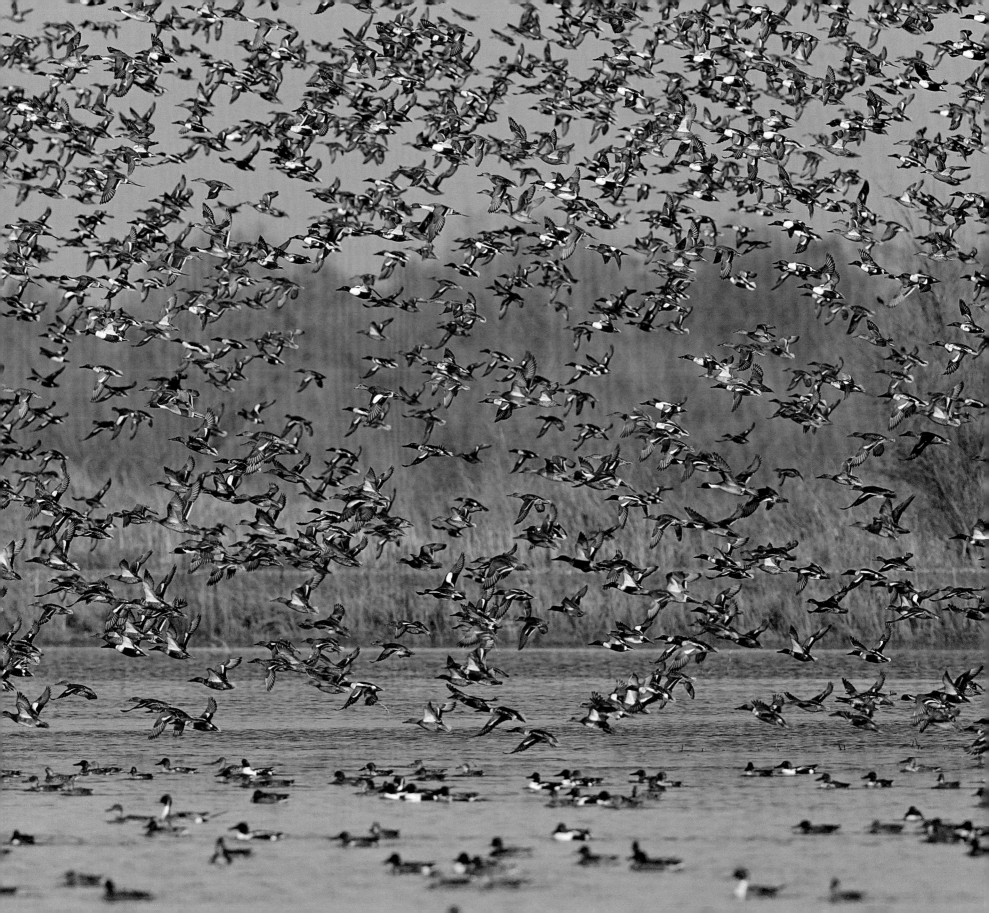

Green and purple hues with a distinct white patch adorn the heads of male bufflehead (*Bucephala albeola*).

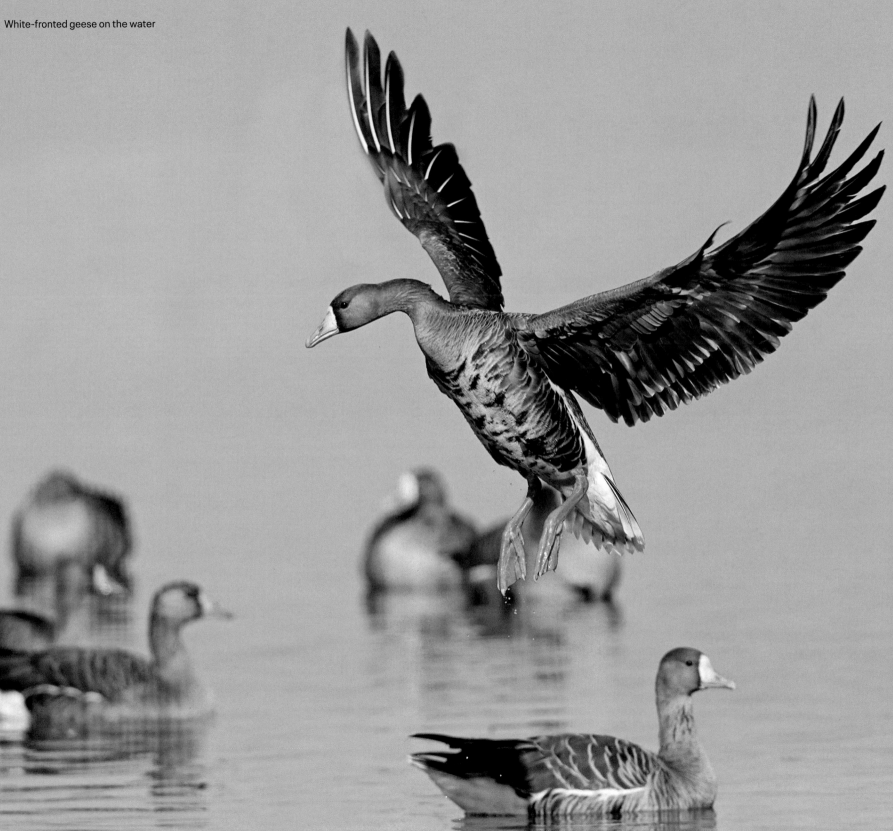

White-fronted geese on the water

Prairie Inspiration

By **Athena Kildegaard**

've lived in the prairie wetlands region of Minnesota for more than twenty years. When we moved to this area, I had little idea how connected I would become to the land and the birds that dot its skies. The poem "Wetland Haibun" and my forthcoming book are both inspired by the wetlands surrounding my home.

Athena Kildegaard is a celebrated poet and a six-time author and lectures for the University of Minnesota Morris.

Wetland Haibun

Eight years ago my husband and I bought thirty-two acres in west central Minnesota—a small foreclosed dairy farm—on the ecotone between oak savannah and tallgrass prairie. The purchase was in many ways a lark, but we sensed it was the right thing to do. The land had originally been claimed by Norwegian settlers over a century ago.

> Who trod this acreage
> before settlers? People clothed
> in land and wild sky.

The Fish and Wildlife Service surveyed our land and suggested three wetland restoration projects. Soon an excavator dredged the eroded topsoil from the bottom of one diminished wetland, collected biomass, and spread it away from the wetland. Some of that mass they used to block the canal that had been cleared to draw water from the wetland into the lake nearby.

> Cattails walk from wet
> to wet. Red-winged blackbirds go
> along, and beaver.

The restored wetland grew and became a habitat and a refuge and a nesting place for migratory birds. The frog population exploded and so did the population of painted turtles. A beaver built a lodge and a pair of sandhill cranes arrived to stand like sentinels on the hill above the wetland. They've returned every year since.

> Mates for life, one clacks,
> one trills, a benediction
> for our shared good life.

Prairie wetlands under a blue sky in the upper Midwest

The Making of
Wings Over Water

By **Chris Dorsey, Dorsey Pictures, Executive Producer**

Chris Dorsey is founding partner of
Dorsey Pictures, a Realscreen Global
100 television production company,
and has served as executive producer
of more than 100 television series
across a dozen cable and broadcast
networks. He's a member of the
Legends of the Outdoors Hall of Fame,
a Curt Gowdy Memorial Award winner,
and a recipient of the Ray Scott
Trailblazer Award.

reating content for the giant screen is often about taking the *ordinary* and making it *extraordinary*. In the case of *Wings Over Water*, however, there was nothing ordinary about the richest waterbird ecosystem on our planet. The landscape-sized mosaic of wetlands and prairies is a gift to our continent from the glaciers that receded after the last ice age some 10,000 years ago. Showcasing the uniqueness of the prairie wetlands and celebrating their importance to hundreds of species, many of which are threatened or endangered, presented the opportunity to capture this remarkable place in all its seasonal glory. The prairies represent an ever-changing visual palette, from their spring green-up through their ermine winter coat. Capturing that beauty along with the mysteries of the birds that depend upon the prairies was the great challenge and privilege of an intrepid team of talented filmmakers who were undaunted by all manner of weather extremes—rain, sleet, snow, and high winds, to name a few.

Every great film starts with a great story, and the prairies have a remarkable tale to tell. Helping us share that story are the stars of our film—three charismatic species: sandhill cranes, yellow warblers,

and the ubiquitous mallard. The life cycle of each species takes it and our viewers to the prairie wetlands. While many people around the world already know of places like the Amazon, Serengeti, and Everglades, most know very little about the most important migratory bird nursery on Earth. Therein lies the mission of this film: to create an awareness of this miraculous prairie habitat. We hope that this understanding will generate an international conversation about its importance that manifests in a movement to preserve the prairies for generations to come.

Telling the story of the massive prairie wetlands while following three distinct bird species on their annual migrations to this vital breeding ground—and doing it all for giant 3D IMAX screens—was a monumental undertaking. Each species presented unique challenges in capturing their long journeys from wintering grounds to the prairie wetlands, and through the rigors of nesting and raising their offspring. Filming required three crews, including Andrew Young, the film's award-winning director and cinematographer, and two of North America's most seasoned natural history cinematographers, Michael Male and Neil Rettig.

**American bison wade
through the water.**

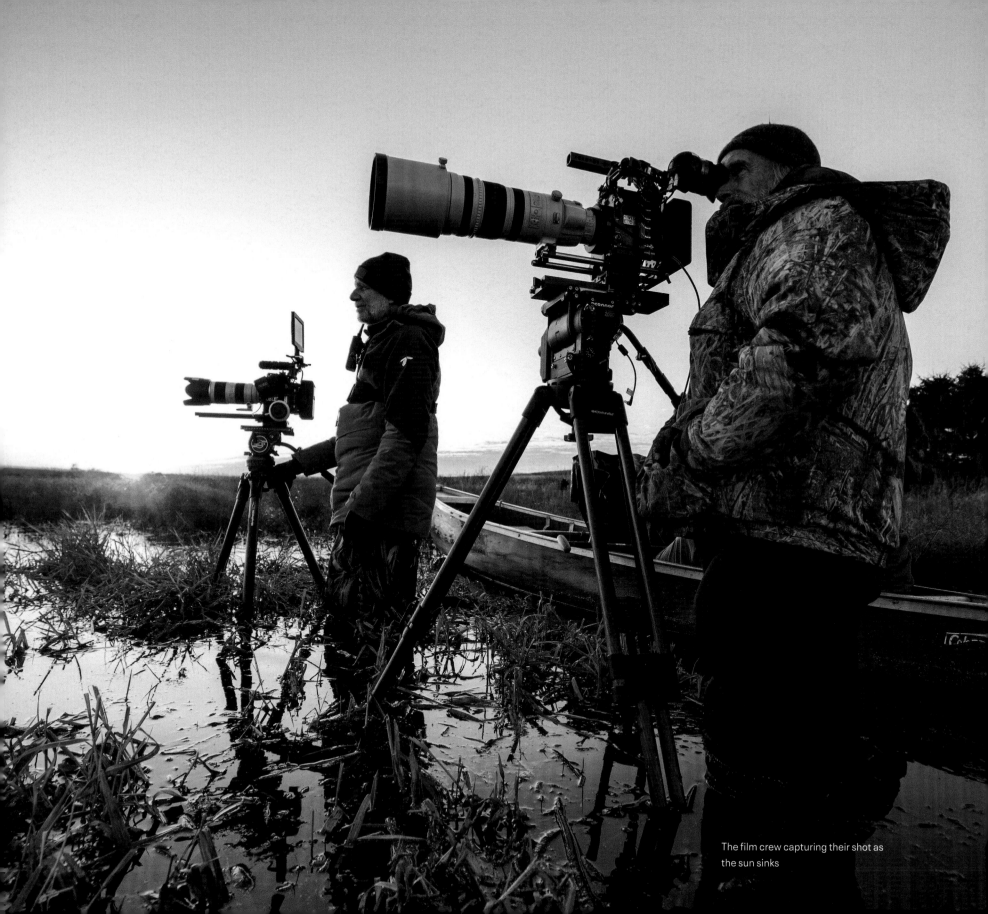

The film crew capturing their shot as the sun sinks

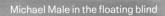
Michael Male in the floating blind

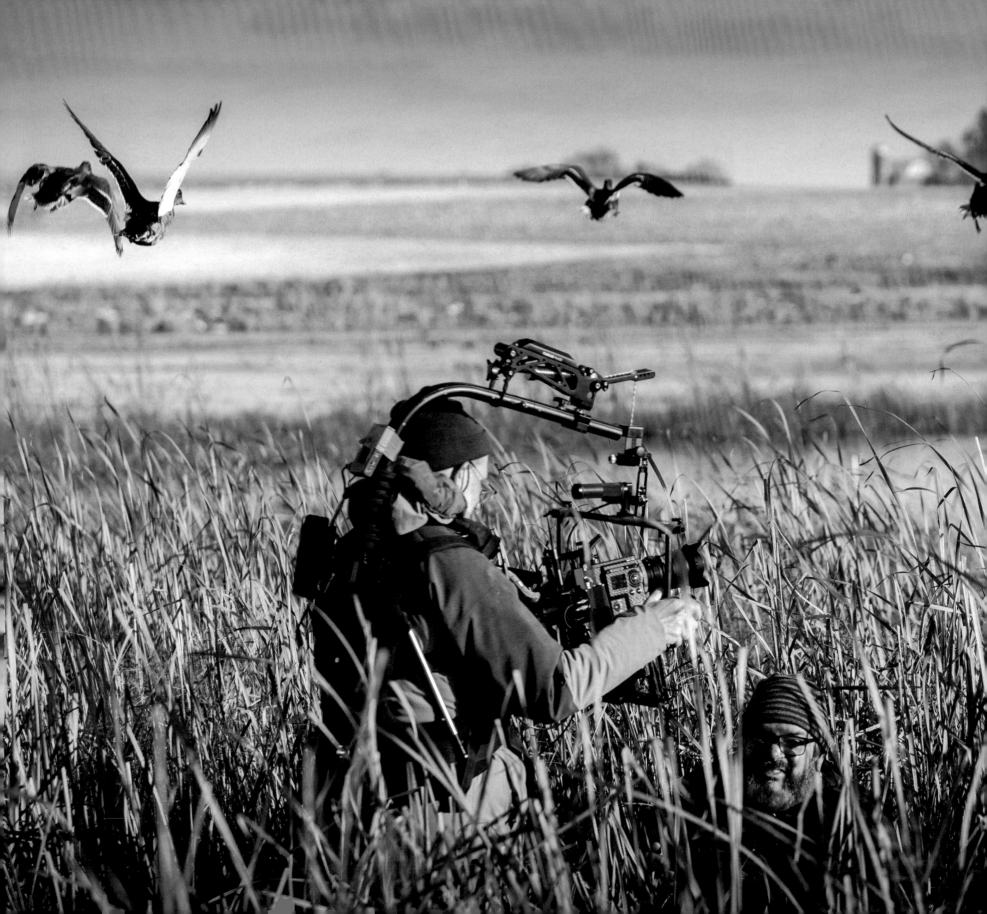

Birds fly overhead as the crew hunkers down in the grass.

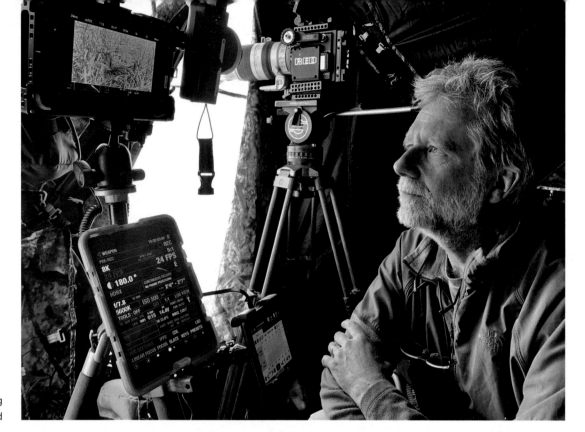

Director Andrew Young
in a command blind

Understanding why this region is so special—each wetland its own unique miracle of life, mostly fresh water but some salt, some permanent but many others seasonal or temporary—begins with a view of this habitat that only the giant screen can deliver. Drilling through the ice of a frozen pothole in winter to film the plethora of microorganisms and other life residing there allows us to transform the giant screen into a window to a seemingly alien world. Bringing close-up images of a 10-inch-long mudpuppy (salamander) to an 80- by 60-foot giant screen transforms the amphibian to something resembling a dragon—and within this transformation lies the immersive magic of IMAX.

As the spring thaw inches across the prairies, the potholes stir with the tiniest of lives, each wetland becoming nature's perfect bowl of soup for migrating waterfowl and other birds. The ingredients, consisting of insects, crustaceans, and other microbes, make up the ideal recipe to help laying hens produce healthy eggs and subsequently provide nutrient-rich food for developing ducklings and other chicks.

Spring is where the story really begins on the prairies, and for Young, that meant filming a hen mallard as she constructed a nest and hatched a clutch of eggs. "We wanted to document the intimate moments of a hen incubating and ultimately hatching her eggs," he says, "so we waited for a hen to leave [her] nest and then hastily positioned a camera rig just 10 feet from her clutch." Their plan was not without risks. "What if she returned early from her afternoon feed and caught us in the act? Would she return to her eggs knowing her cover had been blown?"

The team quickly staked down a small igloo-shaped doghouse so that a strong gust of wind wouldn't blow away the only protection their electronics had from the elements. Then they backed away, covering the cables with grass as they retreated to the command-and-control center—a blind some 150 feet away, filled with more electronics and a display screen linked to the camera. As darkness fell on the prairie, the team returned to their motel, a 45-minute drive away.

"Who in their right mind would leave $75,000 worth of high-end video gear unguarded on the northern prairie overnight, let alone for two whole weeks!" Young says. "Yet there it was."

To take full advantage of the giant-screen format, the team decided to shoot the film in 3D. While providing a remarkable viewing experience, that method comes with many added challenges. To begin with, working in 3D necessitates getting the camera close to

The crew preps a shelter
for their equipment.

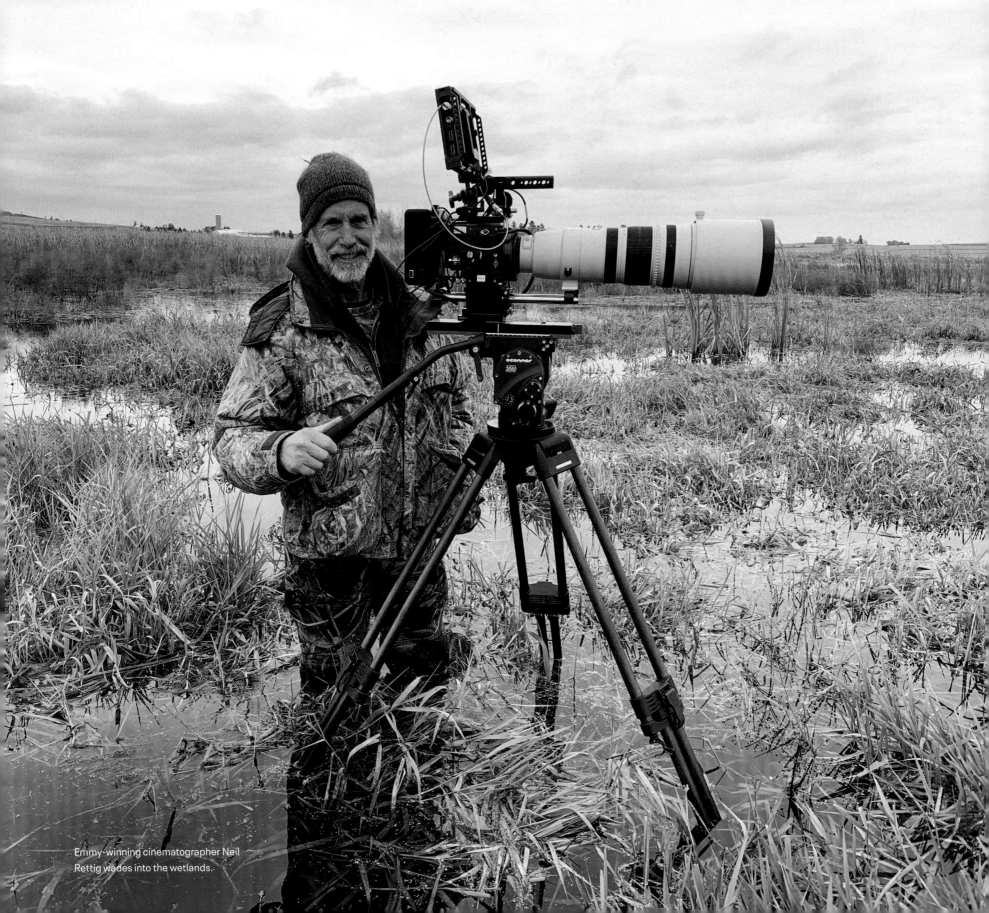

Emmy-winning cinematographer Neil Rettig wades into the wetlands.

This mallard hen grew quite comfortable around Andrew Young.

the subject for full effect, and with birds that often requires a special approach. Michael Male and tech wrangler Brandon Sargeant would return to their blind every day for days on end, swapping batteries, nursing finicky gear, holding down the blind for dear life in high winds, and, of course, watching the hen mallard's every move on the monitor.

"Most important of all, each day when she left to feed, they would sneak in and move the whole rig a little bit closer to the nest, so that by hatching day, the camera had an unobstructed view," Young recalls. "It was a nail-biting assignment, but just one of many that were required to deliver *Wings Over Water 3D* to the giant screen."

Young says that the mallard hen accepted the creeping camera rig thanks to the team's slow, deliberate approach. "It was now barely two feet from the edge of her nest—a front-row seat for the main event," he remembers. "I was scouting landscape shots on the other side of the state when I received Michael's call: 'The hen just went out to feed, and we checked the eggs. They're pipping!'" With the eggs about to hatch, Young jumped in his rental and headed for the highway to join his team for the big moment.

The next morning, the crew crept into the blind before dawn and booted up the cameras, huddling around their seven-inch monitor as the rising sun gave the scene an orange glow. "The hen looked restless, frequently shifting position," says Young. "A little head popped up from beneath the hen's protective wing, then another . . . then two more."

Soon the nest was writhing with a dozen ducklings. Only hours old, they peeped and snapped at ants, knowing exactly what it takes to be a duck. Before long they were as fluffy as cotton balls, and the hen crept out of the nest. After carefully checking in all directions, she issued a quiet, staccato call to her brood. She had their attention at once. They clambered out of the nest for the first time and clumsily pushed through the tall grass, following her to the pond as if their lives depended on it—and because of lurking predators such as raccoons, coyotes, and raptors, they surely did.

While the prairie wetlands are ground zero for this film, it's impossible to tell the story of migratory birds without some road trips . . . lots of them. The crews logged more than 25,000 road miles, spending about 300 days filming at more than 30 locations in the United States, Canada, and Costa Rica (which they were able to access by air before COVID-19 lockdowns gripped the world). In all, the crews captured more than 220 hours of footage that was logged before being edited into the final 44-minute *Wings Over Water*.

Mallards in the grass. The prairie wetlands are where most of the breeding population of mallards can be found.

A gadwall (*Mareca strepera*) family goes for a swim.

The Stars of *Wings Over Water*

MALLARD

Mallards are perhaps the best-known ducks in the world, and with good reason. They're the most abundant wild duck—found across North America, Europe, and Asia—and are the ancestor of most of the world's domesticated ducks. The drake's iridescent-green head and bright-yellow bill are unmistakable.

Mallards are among the largest wild ducks, growing up to two feet long and weighing nearly three pounds. They favor wetland habitats and nest near water, and while they will eat insects, earthworms, and snails, they frequently consume aquatic vegetation and seeds, dunking their heads into the water to do so. For this reason, mallards and similar species are called "dabblers."

Some mallards live year-round in one location, but the majority travel each year from their northern breeding grounds to the central and southern United States and Mexico—the epic journey detailed in *Wings Over Water*.

YELLOW WARBLER

The tiny yellow warbler is a big traveler, able to traverse the entire Gulf of Mexico in a single nonstop flight as it returns to North America after wintering in Central America and northern South America. That's quite an achievement for a bird that weighs less than half an ounce, or less than three sheets of paper!

Both males and females are yellow all over, with black eyes. The adult male can be distinguished by the brown streaking on his chest.

They eat mostly insects and nest in small trees, preferring dense thickets near water. The female's eggs—up to seven at a time—hatch in less than two weeks. And warblers are territorial, chasing away many other species from their nests.

SANDHILL CRANE

With its long neck, rapier beak, and enormous wingspan, the sandhill crane looks like a specimen from prehistoric times—and in a way, it is. Cranes are among the oldest living species on Earth; the oldest known sandhill crane fossil is 2.5 million years old! Individuals can live for more than 30 years.

They get their name from Nebraska's Sandhills region, near the Platte River, where hundreds of thousands of cranes gather each year on their migratory journeys. While some subspecies don't migrate, others fly from far northern Canada to the southern United States and parts of Mexico, often traveling hundreds of miles a day. Their unique trumpeting call often can be heard before the high-flying migrators are seen.

Sandhills are enormous, standing up to four feet tall and with a wingspan that can approach seven feet. Even so, they seldom weigh more than 10 or 11 pounds. They'll eat almost anything, from seeds and grains to small reptiles and mammals.

These cranes mate for life, and a typical nest holds only one to three eggs. Once hatched, the juvenile birds, known as colts, stay with their parents for nearly a year.

Mallards are very social creatures.
The females quack, but the males
make more of a whistling sound to
communicate.

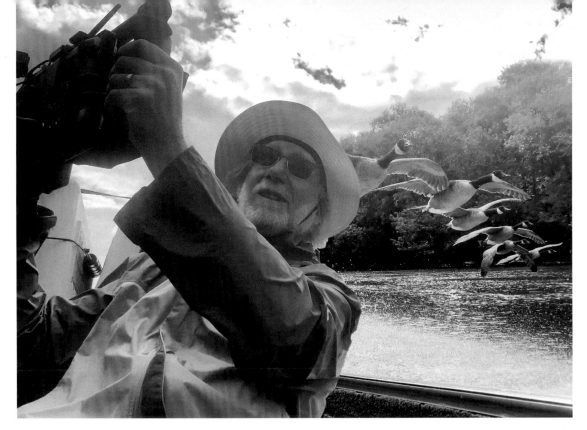

Andrew Young filming geese

"Our van was packed to the hilt with every imaginable tool of the trade, from high-speed and time-lapse cameras, underwater housings, and a drone to remote-control rigs, jib arms, and lenses of every shape and size," Young says. "And of course, lots of chest waders, pop-up blinds, and myriad other paraphernalia."

To attain some of the film's most dramatic flight scenes, the producers created what they dubbed a "bird unit," led by renowned avian trainer Juan Romero. "He's a remarkable birdman," Young says. "He employed a team of imprinted rescue cranes, geese, and ducks that all considered Juan to be their mama."

Those birds and their relationship with Romero allowed the filmmakers to deliver the magical scenes of flying alongside ducks, geese, and cranes using ultralight aircraft, motorboats, and drones. "I will never forget the first time I rode in the back of Juan's pickup," Young says, "as he careened down a grass runway shouting from the wheel, 'C'mon, Buddy! Buddy, Buddy, Buddy!' while a crane named Buddy gracefully beat his giant wings to keep up, flying just inches from my head. Then there was the time we were speeding down the Roanoke River in a bass boat, and a flock of Juan's mallards nearly gave me a haircut."

To achieve some of the intimate underwater scenes, the filmmakers partnered with Sylvan Heights Bird Park in Scotland Neck, North Carolina, where imprinted ducks inhabited a cattail-lined pothole meticulously re-created to simulate a prairie wetland. This allowed cameras to capture certain behaviors important to the life story of the avian stars that were impossible to film in the wild—such as the underwater dabbling of mallards feeding on acorns in a stand of Arkansas flooded timber. Most of the story, however, was captured on location in the prairie wetlands and other spots along the birds' migration, through a combination of persistence, grit, patience, and no small amount of luck.

Any time you're dealing with wild animals there is, of course, no way to predict every behavior or outcome. For instance, after staking out a pair of sandhill cranes at their nest for weeks in pursuit of a hatching sequence, cinematographer Neil Rettig watched, heartbroken, as torrential rains carried off one egg—after it was too dark to film. Or when a parasitic cowbird raided Rettig's featured warbler nest and made off with the eggs one morning at 3 a.m.—again, when it was too dark to film.

"Thankfully, there was also pure magic," says Young, "like the misty mornings Michael Male spent in his floating blind, invisible to the dueling redhead drakes that surrounded him or to the 5,000 sandhill cranes that took flight in unison as an eagle passed overhead—all memorialized through the memory of film."

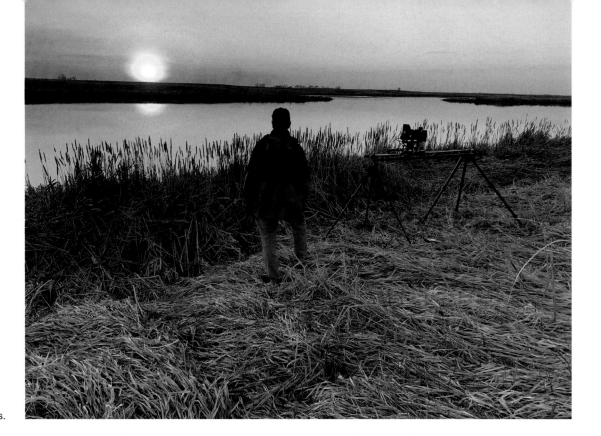

The sun sets over the wetlands.

For a hen to survive the perils of migration, lay a clutch of eggs, and see them through to hatching is nothing short of a miracle. Part of the reason for that is the myriad predators that also call the prairie wetlands home—from raccoons and skunks on the ground to hawks and owls in the air. Representing those threats meant filming other nests and tracking the movements of terrestrial and avian predators. A sequence of a great horned owl gliding just above the prairie grass as it seeks to make a nesting mallard its dinner is one of the film's most dramatic encounters, requiring weeks of planning and preparation to capture a remarkable moment in the life of our prairie wetlands and the predator-prey relationship.

Making an epic natural history film for the giant screen requires miracles—those found in the natural world and those allowing cinematographers to capture the magic. For our filmmakers and producers, the hope is that millions of people will now know of this extraordinary piece of our planet called the prairie wetlands. Instead of looking to the sky at a passing flight of ducks or geese and wondering where they came from, they will know where they are headed, and how special that place is.

The birds that fill our lives with song and beauty will be reminders of the unique prairie wetlands ecosystem—and our responsibility to save it.

On the right: The prairie sky
reflected in the water

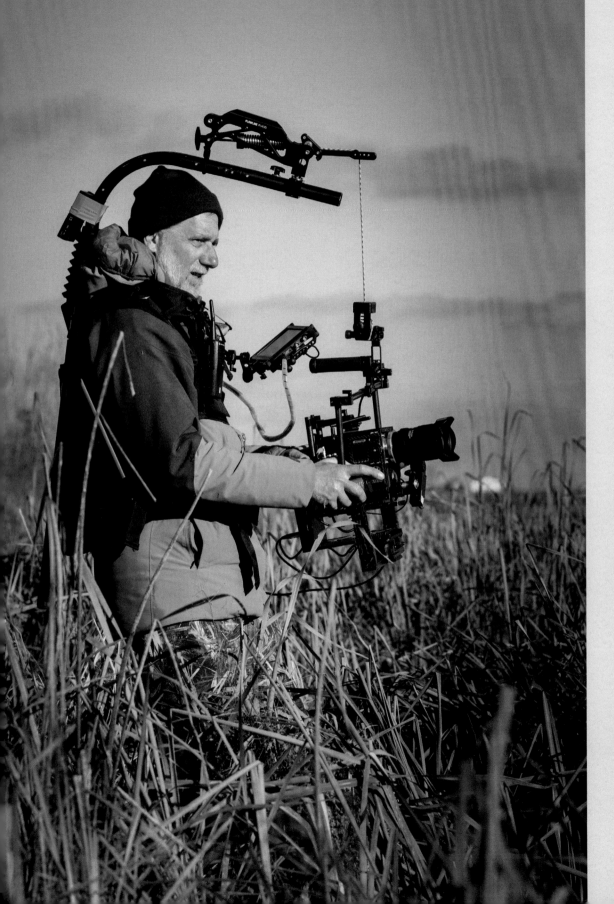

On the left: Ready to capture the shot

On the right: A frost-covered
Neil Rettig hard at work

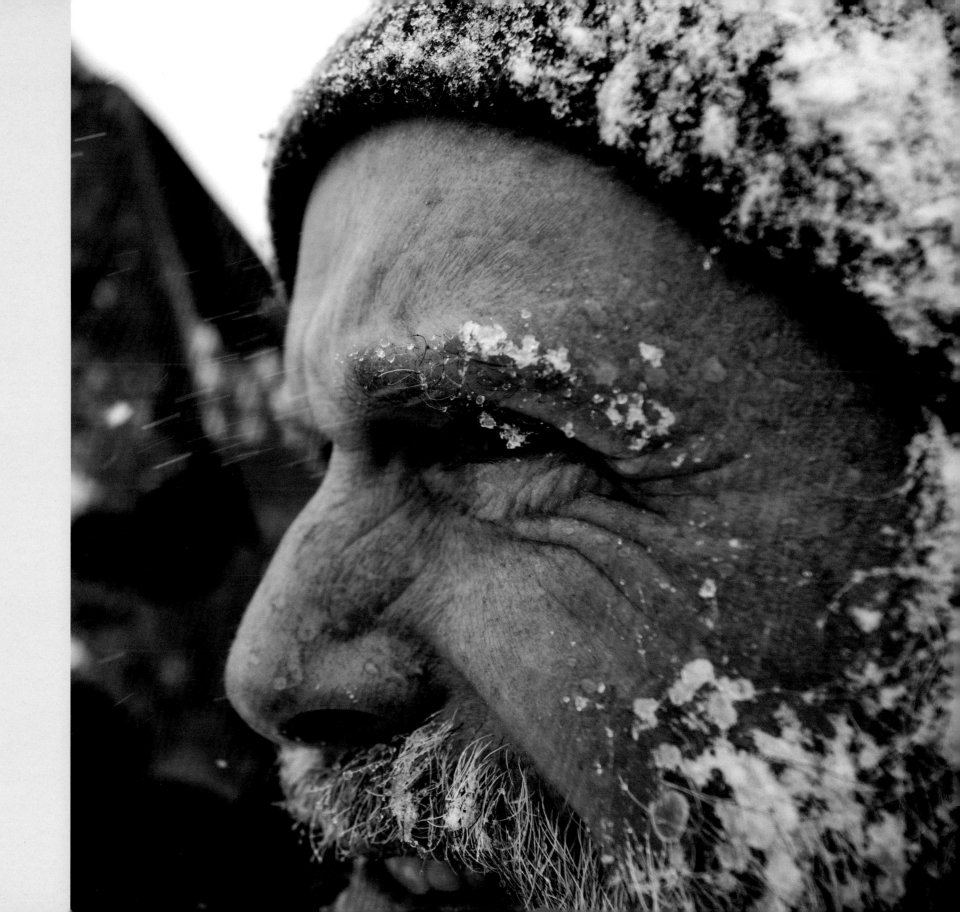

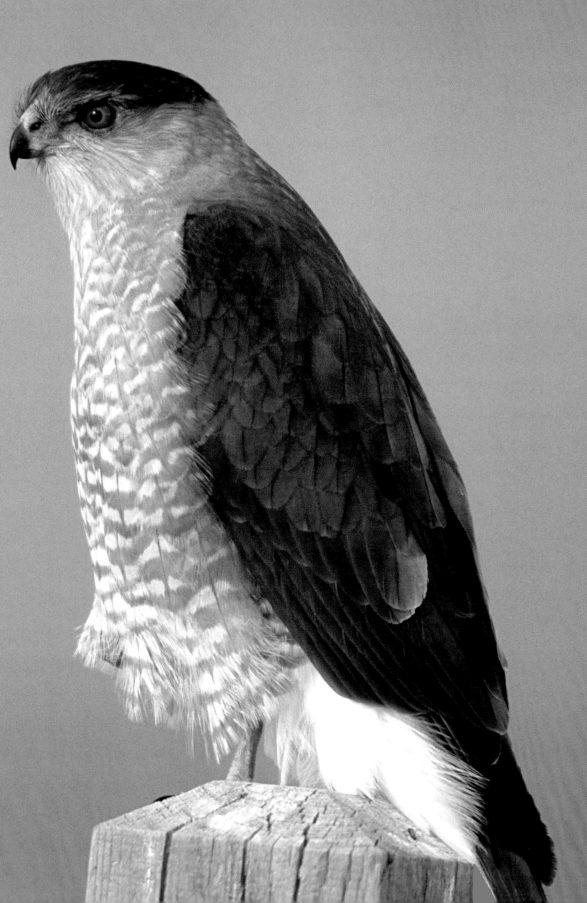

A Cooper's hawk (*Accipiter cooperii*) keeps watch. These hawks eat small mammals and other birds.

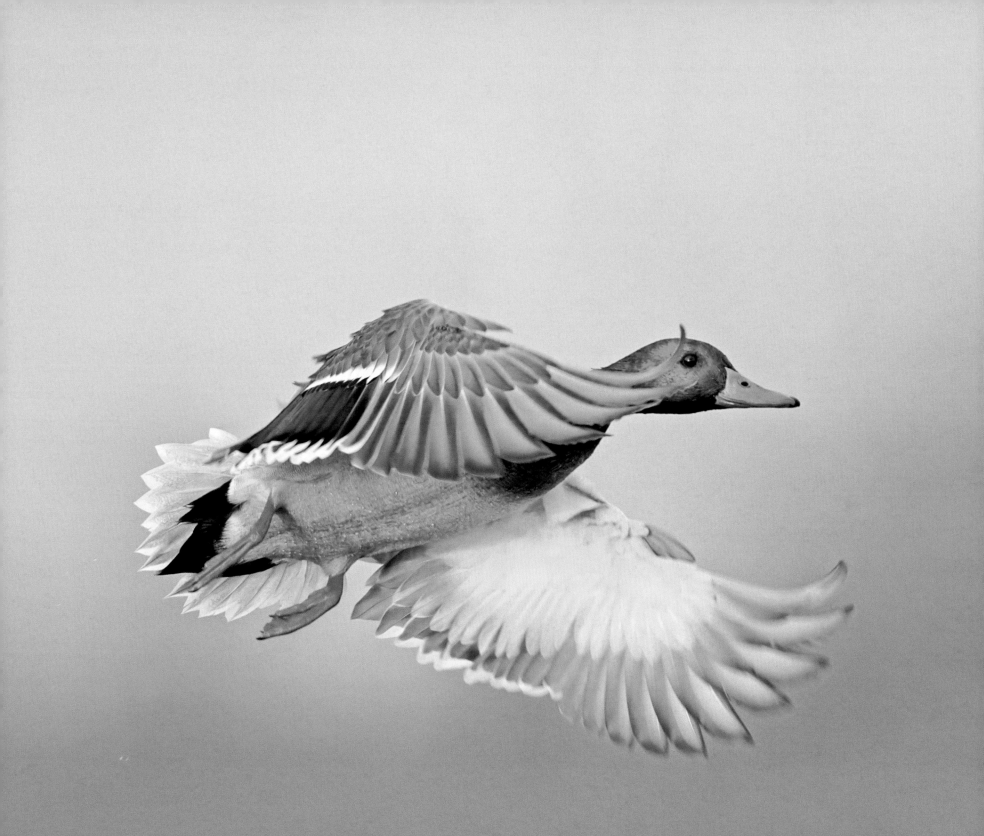

A mallard drake in flight

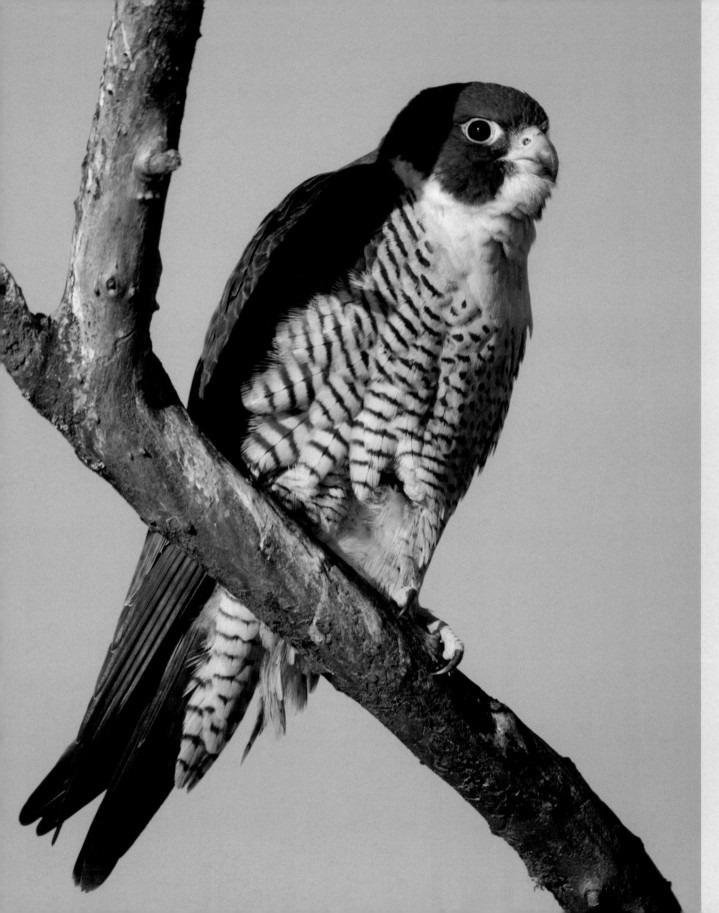

A peregrine falcon (*Falco peregrinus*), one of the prairie's predators

A great horned owl (*Bubo virginianus*) stands over its prey.

A History of Wetlands Conservation

By **John Cooper**

John Cooper of Pierre, South Dakota, received the 2019 Blue-winged Teal Award from the North American Waterfowl Management Plan Committee in recognition of more than 50 years of service to wetlands conservation. From 1996 into 2007, he served as vice chairman of the United States' North American Wetlands Conservation Council.

For nearly 50 years, the prairies have been my office and my home. The wetlands that span the Great Plains—covering parts of five states and three Canadian provinces—comingle with farms and ranches, Native American reservations, rivers, and major dams providing energy in the upper regions of the continent. They are also the duck factory of North America, almost single-handedly supporting the continent's migratory bird populations. Some have compared their ecological importance to that of the Amazon basin and Africa's Serengeti, and while I never have visited those storied places, I can vouch for the prairies. After all, they are my backyard.

In October 1973, I drove from my longtime home in San Bernardino, California, to Bismarck, North Dakota, to begin my career as a special agent with the US Fish and Wildlife Service. During that drive, I thought about what my new job would entail: the enforcement of federal and state hunting regulations and myriad other responsibilities, possibly including undercover work.

Upon arrival, I met with the Fish and Wildlife Service's area office director, Jim Gritman, and his assistant, Lyle Schoonover. Their message surprised me. Instead of talking about poachers and felonies, they said they needed me and other special agents to help protect our prairie wetlands.

At that time, the US Department of Agriculture promoted large-scale industrial farming. Critical ecosystems, including wetlands, were being swiftly removed, allowing more land to be plowed and cultivated. The easiest targets were temporary and seasonal wetlands, which filter and purify water and provide essential breeding habitat for the continent's migratory birds.

The only bulwark against this was the federal Small Wetlands Program, which protected the wetlands through conservation easements. But as Jim Gritman told me, "We're losing that battle." Many wetlands, he added, were being drained illegally.

Those conversations turned out to be prescient. Beginning in 1974, working with federal prosecutors in the Dakotas and the US

A full rainbow over the prairie

Department of the Interior, the other special agents and I opened more than 420 cases against people who had violated the terms of their wetlands easements. At times it seemed that our own government was working against us. Under the leadership of Earl Butz, the Department of Agriculture had instituted a series of policies to drive grain production, leveraging foreign sales and a reduction in the United States' trade deficit. Butz urged farmers to plant even the most marginal ground "fence row to fence row," and his message fell on receptive ears.

Agricultural technology had advanced significantly since the first farmers arrived on the landscape, and huge four-wheel-drive tractors and other equipment easily cracked the crust of the native grasslands and made draining wetland basins simple. Shelterbelts and windbreaks fell, either to tractor blades or to fire.

We should have known better. These same sorts of practices in the 1930s created the Dust Bowl, when the prairie winds swept up bare topsoil and sent it billowing in great dark clouds across the continent. I saw similar effects during the early 1970s as the winds scoured the bare fields that had been plowed in the fall to allow early planting come spring.

Farmers and conservation officials alike referred to those years as the "Wetland Wars." We faced severe political opposition from people who wanted the easements terminated and the agents barred from private lands. Some of them called me and my colleagues "the Duck Mafia"—intended as an insult, but we considered it a compliment.

By the mid-1970s, though, the picture was clear: if we wanted to help waterfowl and other migratory birds on these critical prairie breeding grounds, we needed to do more than simply enforce the rules. We had to increase funding and change the focus and scope of land management plans to address the increasing loss of wetlands throughout the United States and Canada.

It would be impossible to detail here the combined efforts that went into framing and adopting the North American Waterfowl Management Plan, the result of that recognition. To summarize, the stage was set by the farm crisis of the mid-1980s. The earlier push to farm every bit of available land had resulted in significant overproduction of wheat and corn, knocking prices to record lows. Farmers were overextended on their loans and facing foreclosure at a significant rate. The banks, alarmed at the growing threat of

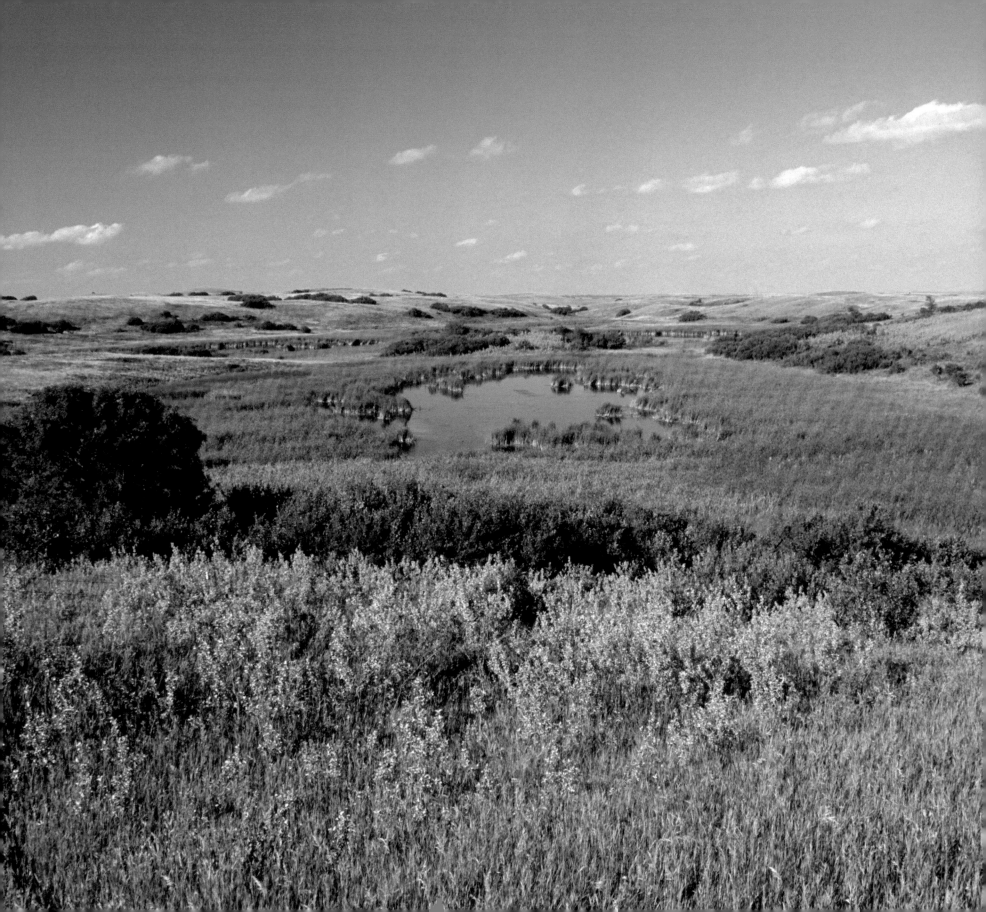

loan defaults, turned to Congress and demanded that it find a way to solve the problem. Congress began focusing on programs that would take marginal farmlands out of production, safeguard water quality, and reduce erosion—and take pressure off farmers and the banks. The 1985 Farm Bill embraced the Conservation Reserve Program, creating the first set-aside lands since the USDA Soil Bank Programs in the mid-1950s.

On the heels of the Farm Bill, after nine years of tedious work involving political, agricultural, and environmental leaders, the United States and Canada signed the North American Waterfowl Management Plan in 1986, and Mexico joined in 1994, creating a tripartite agreement to scientifically manage the continent's waterfowl and their habitats.

The plan is little known outside the conservation community and can be hard to comprehend without a background in wetlands and waterfowl. But it can be described fairly as the bible for waterfowl managers, and it accurately captures the objectives for migratory bird population goals and conservation measures for the ecosystems needed to maintain those populations. It sets forth the mechanism of regional partnerships known as joint ventures, charged with developing and delivering conservation plans for wetlands

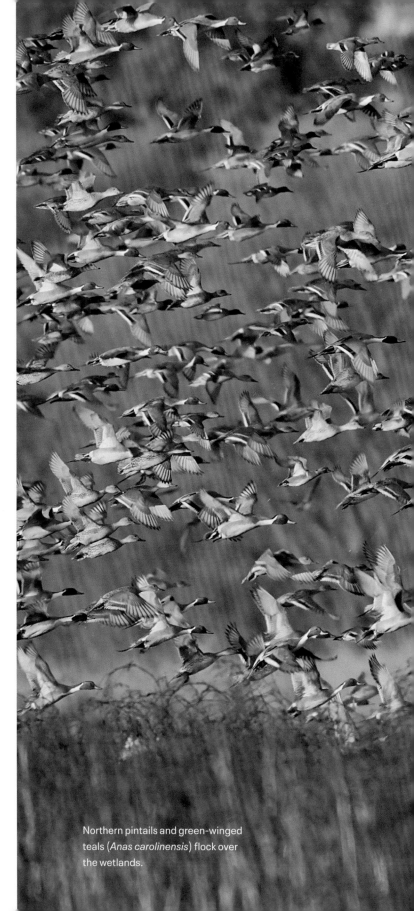

Northern pintails and green-winged teals (*Anas carolinensis*) flock over the wetlands.

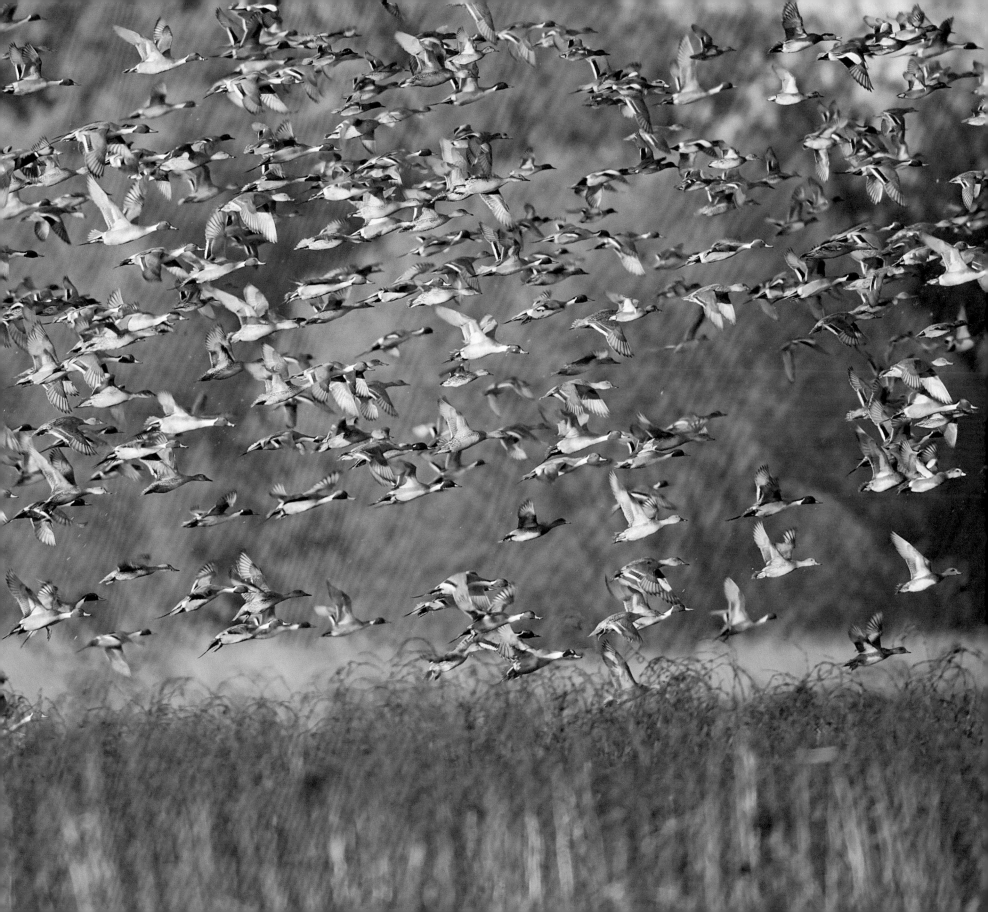

What Is the North American Wetlands Conservation Act?

Among the grandest programs in conservation history, the North American Wetlands Conservation Act was launched by Congress in 1989. NAWCA provides funding to drive the North American Waterfowl Management Plan, an agreement among the United States, Canada, and Mexico to protect wetlands and other habitat necessary to sustain the continental populations of waterfowl and other migratory birds.

NAWCA is a voluntary program that enables public/private partnerships to protect, restore, and manage wetlands. These habitats help people as well as wildlife by reducing soil erosion, mitigating floods, recharging aquifers, and helping to improve overall air and water quality. Some of the habitats protected by NAWCA also provide recreational opportunities for hikers, hunters, anglers, photographers, and bird-watchers.

The funding is provided in the form of competitive grants that require applicants to match every federal dollar. In many cases, the recipients provide double or even triple the federal funding. Each year, the North American Wetlands Conservation Councils in the US and Canada review and rank the grant applications. They are then considered by the United States' Migratory Bird Conservation Commission, which has final approval.

To date, NAWCA has helped finance more than 3,000 projects covering 30 million acres of habitat in all 50 states and parts of Canada and Mexico. Nearly $2 billion in grants have been awarded in the past two decades, and recipients have provided nearly $4 billion in matching funds.

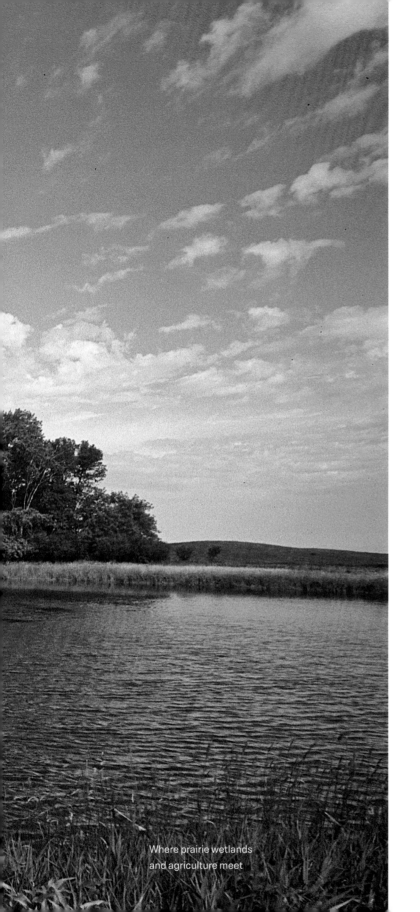

Where prairie wetlands
and agriculture meet

and grasslands. In short, it is the comprehensive needs assessment for protecting waterfowl and related habitats while supporting recreational and ecological benefits for the continent's human populations.

The plan defines the continuing loss of key habitats, the increasing challenges to maintaining the habitat base that we have now in comparison to the past, and the growing need to ensure the funding to support those habitat efforts. But to address that funding requirement, another landmark program would be needed, uniting federal, state, provincial, and nongovernmental entities working toward common objectives. Enter the North American Wetlands Conservation Act. Without it, we would have no practical means to save wetlands and the birds that rely upon them.

I had the privilege of helping to create NAWCA's regulatory framework and helped shepherd it through Congress, and I will never forget the celebration when President George H. W. Bush signed it into law in 1989. Under NAWCA's provisions, millions of dollars flow throughout the United States, Canada, and Mexico to restore and sustain wetlands. Conservation partners in every region provide matching funds, multiplying the money's impact.

A pair of gadwalls on the move

The organization and delivery of NAWCA were among the most satisfying achievements that I witnessed in my career. The combined efforts of the US Fish and Wildlife Service, state natural resource agencies, and conservation organizations such as Ducks Unlimited, the National Audubon Society, and others drove its passage faster than any other major program I can remember. After its passage, the USFWS Division of Bird Habitat Conservation, Ducks Unlimited Canada, and the North American Wetlands Conservation Councils in the US and Canada rapidly established the necessary procedures and safeguards to ensure that the money would be spent well and efficiently.

The results have been gratifying. Since its passage, NAWCA has helped to restore, protect, and enhance almost 30 million acres of habitat. It has funded more than 3,000 projects with nearly $2 billion in grants, while more than 6,000 partners have generated more than $3.75 billion in matching dollars. More than 30 years after its passage, it is one of conservation's grandest success stories.

The conservation of North America's prairie wetlands has been the common thread of my career—23 years with the US Fish and Wildlife Service, followed by 19 years as cabinet secretary and commissioner for South Dakota Game, Fish and Parks. I was honored to serve on the North American Wetlands Conservation Council, charged

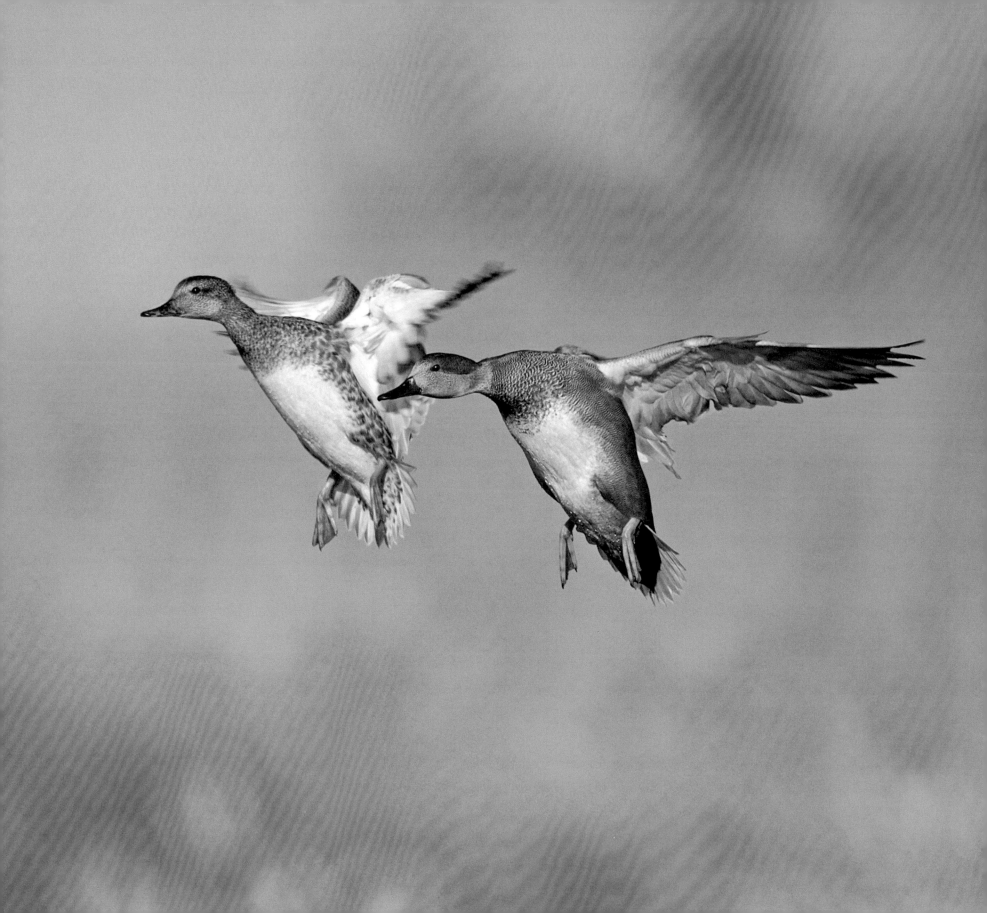

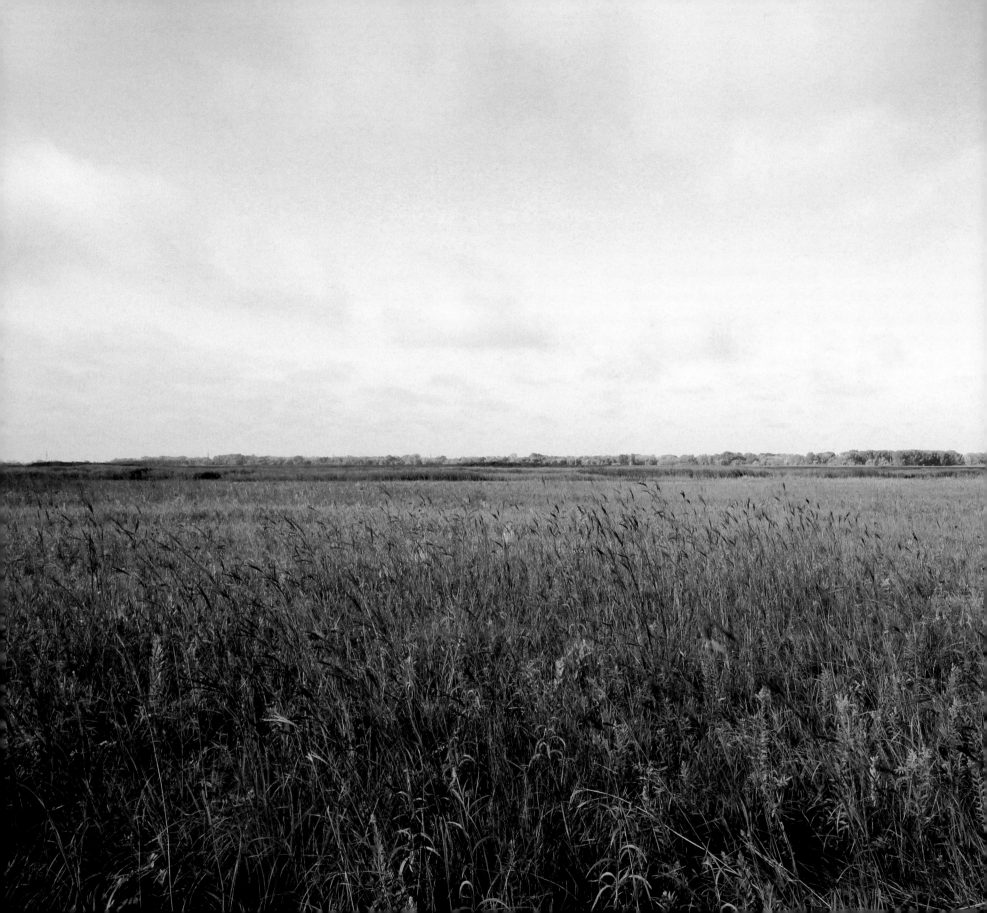

Hues of red, gold, and green form this prairie landscape.

with coordinating wetlands policy in the United States and Canada. Even today, in my retirement, I have been proud to work with scores of scientists, resource managers, and volunteers, all dedicated to protecting migratory birds and the habitats they need.

I learned from giants such as Harvey Nelson, who served the US Fish and Wildlife Service for more than 40 years and was the first director of the North American Waterfowl Management Plan; Rollie Sparrowe, then the federal chief of migratory bird management; Keith Harmon of the Wildlife Management Institute; and Dr. Jim Ringelman, a North Dakota–based scientist for Ducks Unlimited who spent years helping to plan and revise the North American Waterfowl Management Plan.

Carl Madsen, a federal prairie and wetland specialist, is the most adept person I have known when it comes to hearing private landowners' concerns and designing commonsense programs for conservation. Lastly, there was Terry Gross, my supervisor as a special agent and a colleague for more than 20 years. We shared a passion for migratory birds and their habitats and spent uncounted hours working to halt easement violations in the Dakotas and Minnesota.

These conservationists, and many others, had a profound influence not only on me but on the wetlands of North America. They inspired me then, and they inspire me today.

Whether you are a bird watcher, a waterfowl hunter, or a citizen who wants clean water and a healthy environment, you have benefited from this work. You also have gained from the work of such diverse groups as Ducks Unlimited, Ducks Unlimited Canada, Audubon, Partners in Flight, the American Bird Conservancy, and Delta Waterfowl. NAWCA and its programs are a tremendous example of targeted, effective conservation accomplished through the efficient use of government and private dollars—I witnessed it, and I will defend it.

If there is one disappointment from my tenure, it is that we conservationists have failed to sufficiently explain to the public the need for wetlands protection, particularly regarding our prairies. That message is increasingly important, as bird populations and habitats are under more pressure than ever because of human population growth and the concurrent global demands for food, energy, and fresh water, as well as the indisputable effects of climate change. All of this suggests that the prairies will be under more pressure as the years advance.

Significant wetland habitat is drained every year, and bird populations are dwindling. I suspect that the citizens of the United States and Canada would be worried about this, if only they knew about it.

This concern prompted me to join a team of other conservation leaders assembled by the Max McGraw Wildlife Foundation to review the North American Wetlands Conservation Act's many accomplishments, particularly on the Canadian prairies. We completed our work with a heartfelt recommendation that somehow we had to find a way to teach the general population about our prairie wetlands—an ecological treasure to rival any on the planet, yet largely unknown and unheralded.

The prairie wetlands and their wildlife have given me a fulfilling career, immense satisfaction, and above all, an overwhelming desire to share their story. I have watched the sun rise over the prairies and seen the tremendous flocks of ducks, geese, cranes, shorebirds, and songbirds rise from their waters. I have sat transfixed as night takes over the wetlands and the birds head for their nests to guard their young and rest for their journeys ahead.

And each fall, I watch as the flocks of birds leave the prairies and head south, and I pray that there will be sufficient wetlands to greet them when they return in spring.

You Can Help Save the Prairies

After reading this book or seeing the movie, you may be wondering how you can protect the prairie wetlands. A good place to start is learning about the organizations working to protect this habitat. Ducks Unlimited, Ducks Unlimited Canada, and the National Audubon Society are among the leading organizations working to ensure that the magnificent North American prairie wetlands remain vibrant for generations to come. Those three groups partnered with the Max McGraw Wildlife Foundation to produce the IMAX 3D film *Wings Over Water*.

Many other groups on the local and national levels in the United States and Canada recognize the significance of this ecosystem for wildlife and humans and are working to protect it. Supporting those organizations' conservation efforts is one way to help preserve the prairies.

Buying a Federal Duck Stamp is another effective way to protect wetlands in the United States. Fully 98 percent of every dollar spent on the duck stamp goes toward the acquisition and protection of habitat. Canada has its own Wildlife Habitat Conservation Stamp, as do many states and provinces.

On the governmental level, the most important pieces of legislation to protect wetlands are the North American Wetlands Conservation Act and the US Farm Bill, which includes important measures offering landowners compensation for putting lands under conservation management. By supporting these and other legislative efforts that encourage conservation, you will help ensure the prairie wetlands' future.

Wading through the wetlands as the sun sinks

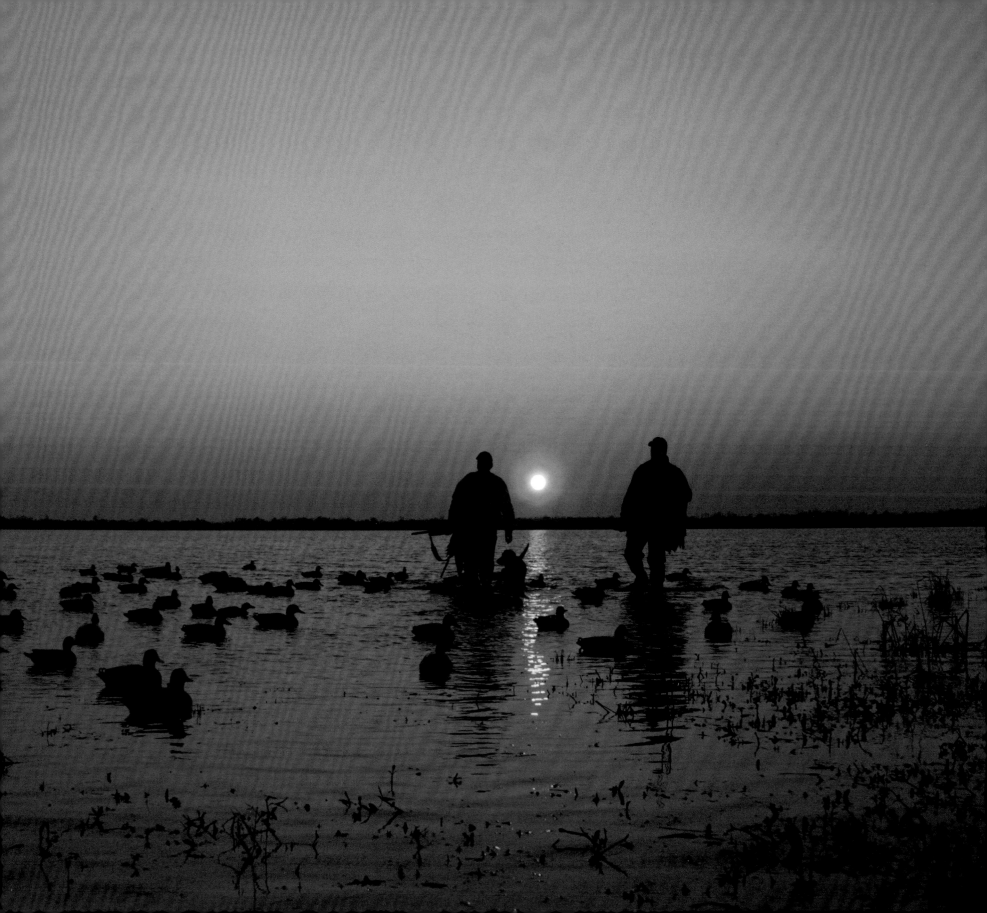

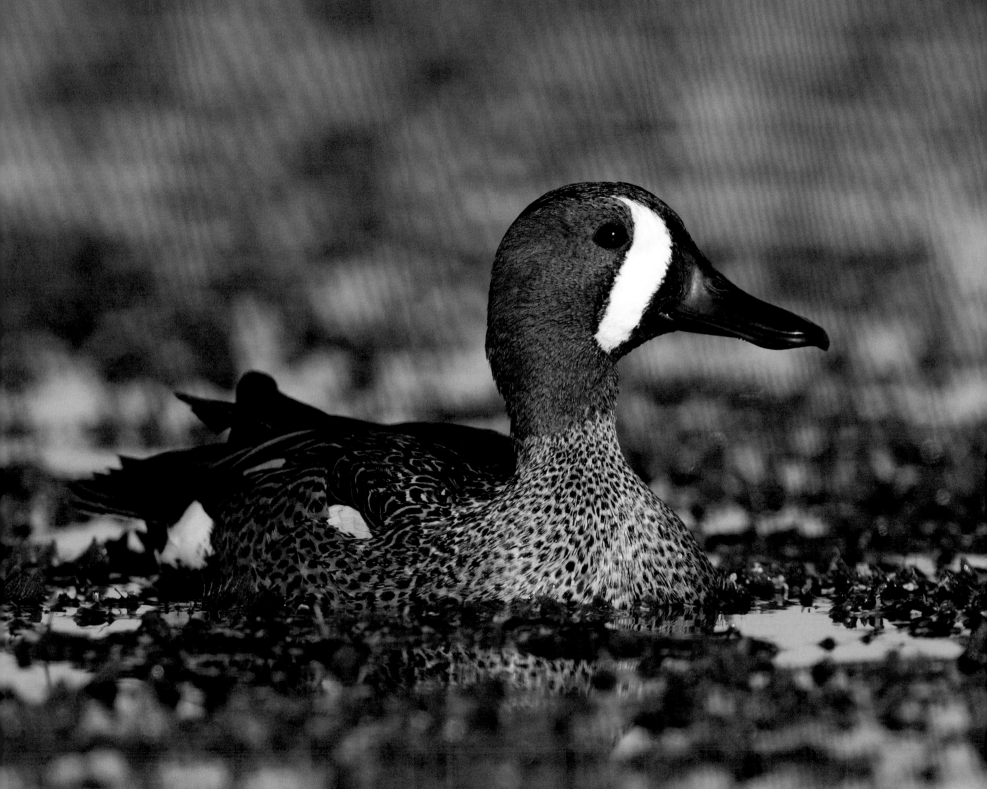

Blue-winged teal (*Anas discors*)

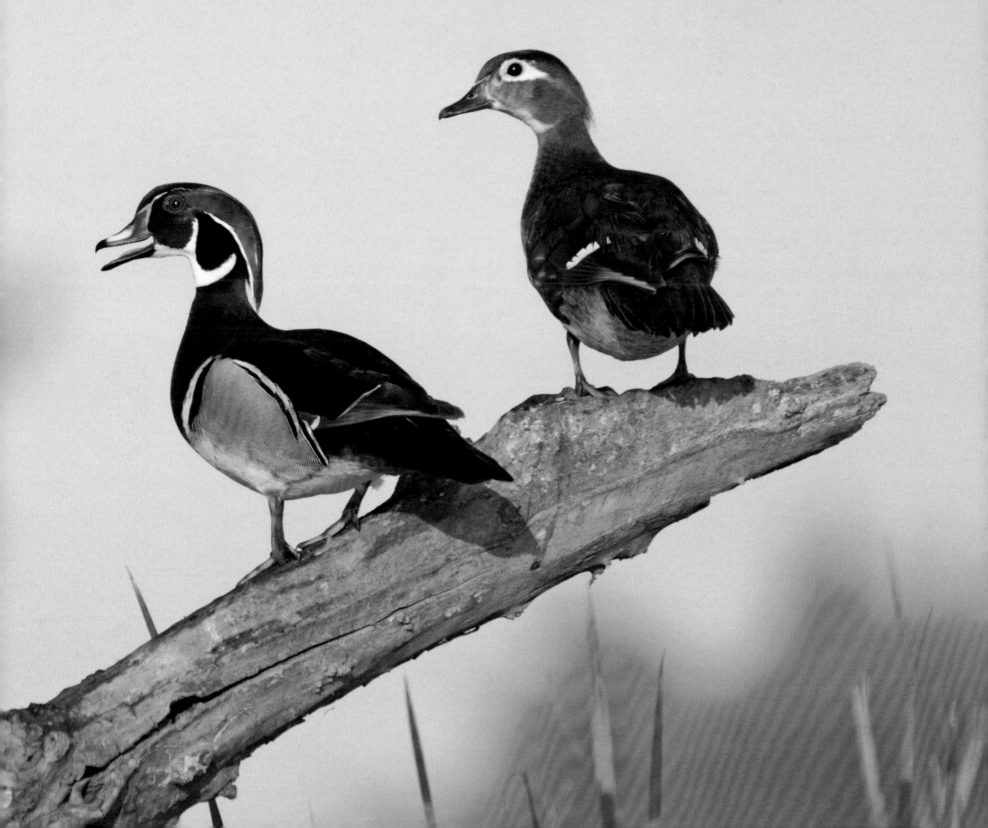

A pair of wood ducks (*Aix sponsa*) share a perch.

Blue-winged teals in flight. Blue-winged teals are among the smallest ducks living in North America.

A northern pintail and her ducklings take a swim.

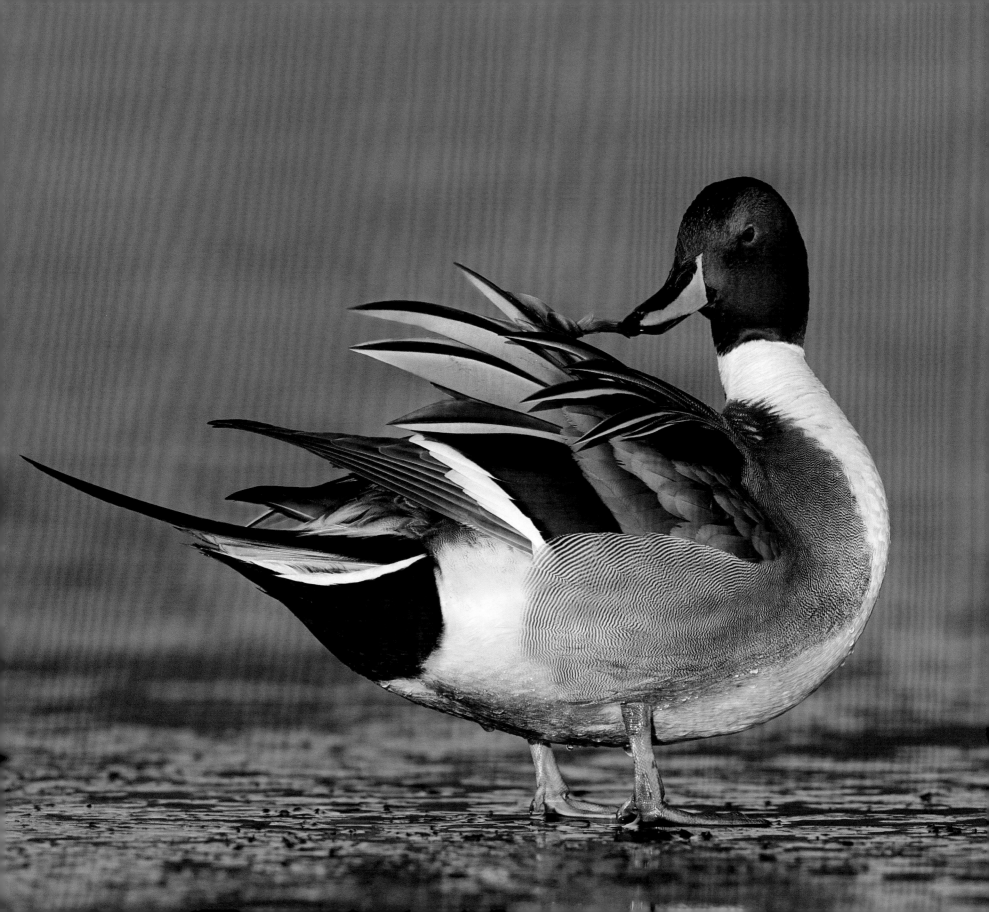

A northern pintail preens his feathers.

The Unlimited Wonder
of Waterfowl

By **T. Edward Nickens, Ducks Unlimited**

*For more than three decades,
T. Edward Nickens has reported on
conservation, the outdoors, and
Southern culture for some of the world's
most respected publications. He is a
contributing editor for Ducks Unlimited,
Audubon, and* Garden & Gun *magazines
and editor-at-large for* Field & Stream.
*He lives in Raleigh and Morehead City,
North Carolina.*

When the birds lift from the water, the ground shakes as if it were possessed with thunder. The sound of a thousand beating wings grumbles across the prairie, and the horizon smokes with the rising skeins of waterfowl. Listen closely and you can hear the quacks and whistles of mallards and wigeons and teals. Breathe deeply and you can catch whiffs of mint, sage, and sweetgrass, the crisp scents of the coming winter. On a prairie wetland, when the ducks boil from the water, the spectacle ignites the senses.

Gouged by receding glaciers, these often-ephemeral ponds and sloughs and prairie lakes are the gifts of deep time. Like the redwoods of the Pacific Northwest, the Rockies, and the soaring highlands of the Blue Ridge Mountains, this region—the Prairie Pothole Region—is a natural treasure whose impacts are felt in far distant places. Approximately 7 out of 10 birds that migrate over North America rely on prairie wetlands during part of their life cycle, and the dividends they pay arrive in winged storms over marshes, lakes, rivers, swamps, sloughs, and coastline shores in every state and county across the US and far, far beyond.

It's a sight and a feeling and a wonder that has long been treasured by those obsessed with sunrises and feathers. For too long this region has been little understood, and even disregarded, by many. With the advent of *Wings Over Water*, the Prairie Pothole Region is poised to be the next iconic landscape to sweep a new generation of conservationists into its thrall.

Thankfully, the foundation for this region's protection was laid more than 80 years ago.

Organized in 1937, Ducks Unlimited was founded to be a guardian of that vast plain of grasslands and innumerable sparkling ponds, and a shepherd to its incredible array of bird life. "DU and the prairie wetlands share a kind of genetic makeup," explains CEO Adam Putnam. "Our work and our members' passions are so deeply rooted in the prairie potholes that it's almost impossible to separate the

A plump of redheads
(*Aythya americana*) in flight

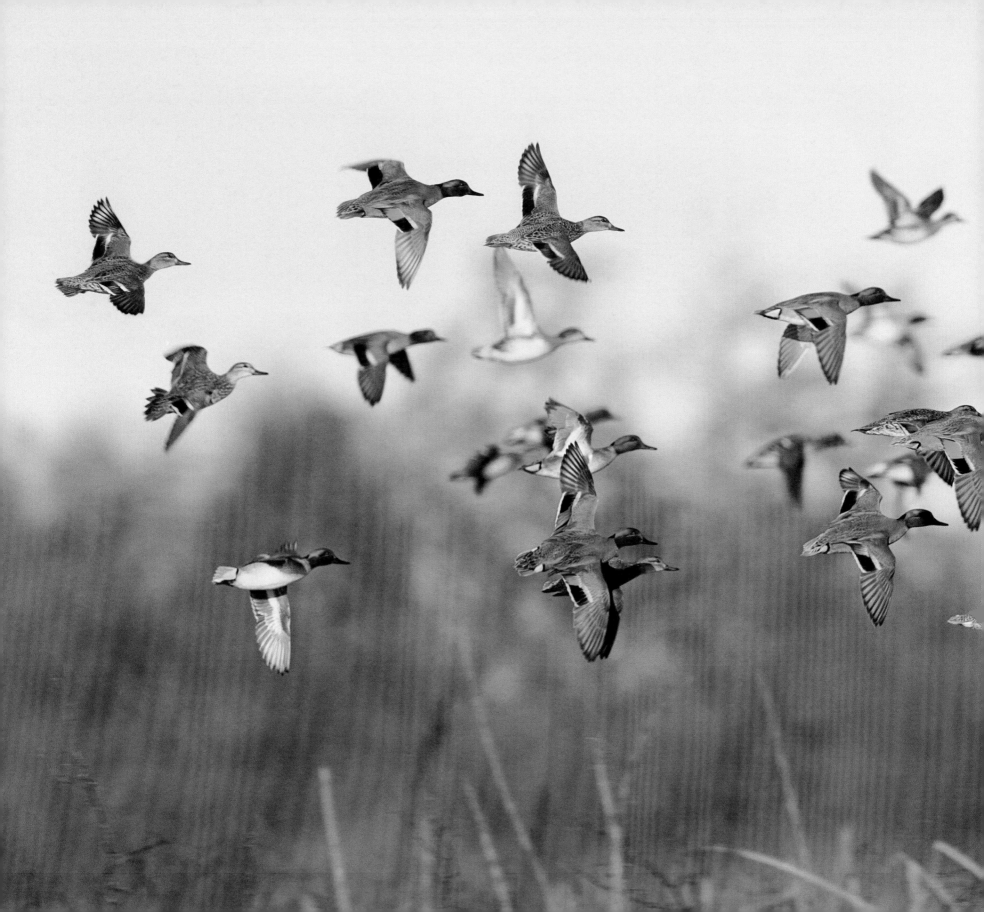

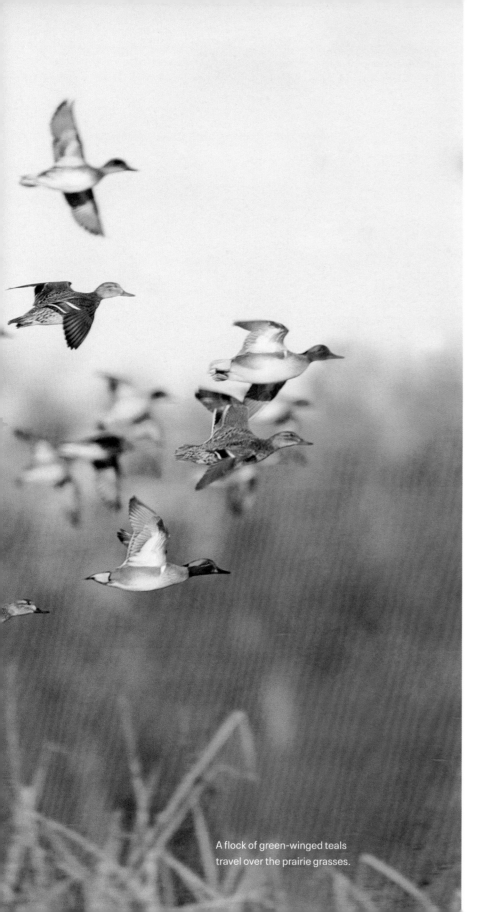

A flock of green-winged teals travel over the prairie grasses.

two." Given the impact DU has had, and continues to have, on the so-called "duck factory" of North America, it's a relationship that will provide even greater benefits in the future.

In 1938, the year-old organization made $100,000 available for prairie pothole restoration in Canada. The sum was equivalent to $1.5 million in today's dollars and is an even more remarkable figure given that the Great Depression was still debilitating economies worldwide. DU's first project was the restoration of the Big Grass Marsh in Manitoba, a vast sweep of prairie wetlands that had been drained for agriculture decades earlier. The first shovels went into the ground within days of the project's approval. The first water flowed back to the Big Grass Marsh project within a month. Today, thousands of ducks and sandhill cranes can be found on the restored wetlands during migration.

And so it began: acre by acre, dollar by dollar, with a growing army of volunteers, scientists, policy professionals, and dedicated staff, DU engaged in an international effort to restore wetlands, which provide clean water and support boundless hosts of wildlife. For nearly 50 years, DU's sole focus was on the breeding grounds north of the US-Canada border and, to a lesser extent, wintering grounds

in Mexico. But in 1984, the organization spread its own wings. DU had grown into an astonishing movement with some 400,000 members and nearly $150 million spent on behalf of birds. When the organization's US habitat program was launched in North Dakota, the first project was to create a nesting island in Lake Arena. More followed, and quickly: 4,700 acres of restored wetlands in Missouri, a 695-acre tract of freshwater wetlands and old rice levees purchased in South Carolina, a massive levee protecting an 8,000-acre impoundment on public lands in Louisiana repaired after extensive hurricane damage.

"It was critical to invest in waterfowl habitat south of the US–Canada border for many reasons," says Pete Coors, who served as DU's president during the expansion. "We wanted to underscore the importance of all wetlands across the continent. And we were intentional in deepening the connection between waterfowl hunters and close-to-home habitats that were so important to ensuring a legacy of hunting and conservation."

Today, DU has raised more than $5.7 billion for conservation and restored or protected more than 15 million acres of habitat. Such success has garnered high praise while delivering on-the-ground

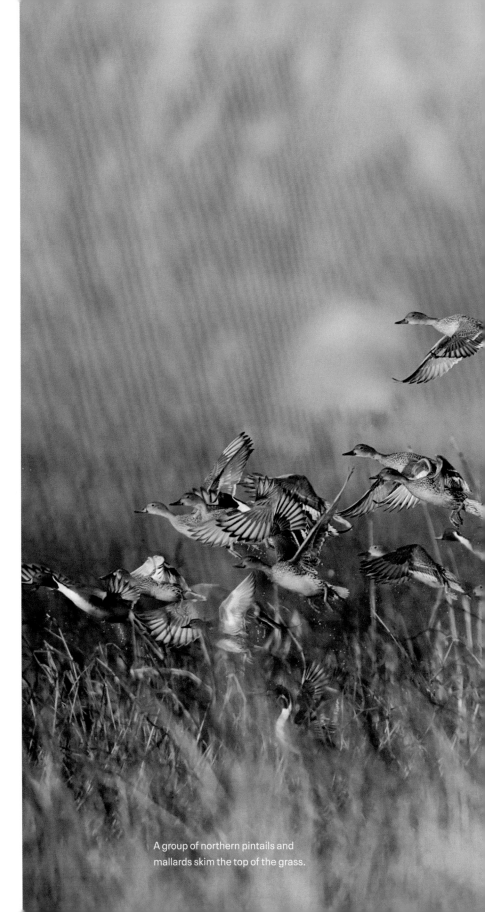

A group of northern pintails and mallards skim the top of the grass.

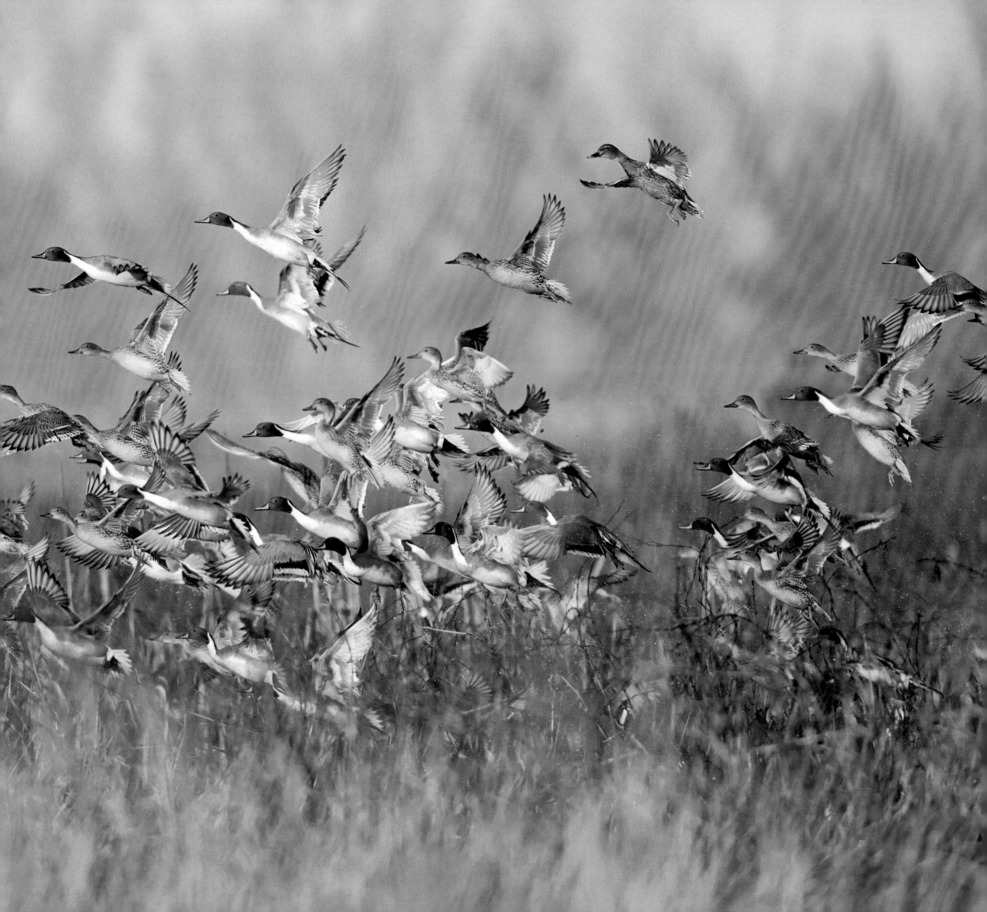

About Ducks Unlimited

Ducks Unlimited Inc. is the world's largest nonprofit organization dedicated to conserving North America's continually disappearing waterfowl habitats. Established in 1937, Ducks Unlimited has conserved more than 15 million acres, thanks to contributions from more than a million supporters across the continent. Guided by science and dedicated to program efficiency, DU works toward the vision of wetlands sufficient to fill the skies with waterfowl today, tomorrow, and forever. For more information on our work, visit www.ducks.org.

About Ducks Unlimited Canada

Ducks Unlimited Canada is one of North America's largest and longest-standing conservation organizations. We conserve, restore, and manage wetlands and other natural areas to benefit waterfowl, wildlife, and people—a mission we've been pursuing with passion and determination since 1938. Our organization's success and longevity is rooted in our commitment to forming partnerships and finding solutions that benefit the environment and the economic and social health of the country as well.

Sportsmen, specifically waterfowl hunters, founded DUC during the decade-long drought of the "Dirty Thirties," as wetlands across prairie Canada disappeared and waterfowl populations plummeted. Our founders recognized that conserving wetlands helped ensure the future of the birds they loved, and set out to stop the destruction of Canada's wetlands by initiating conservation projects and raising funds to support these efforts.

Today, DUC is supported by a wide range of people and organizations concerned about water, wildlife, and the environment. They include governments, industry groups, Indigenous peoples, other nonprofit organizations, and landowners who partner with us to deliver conservation in every province and territory. We proudly collaborate with Ducks Unlimited organizations in the United States and Mexico to deliver conservation on a continental scale. Operating independently, but with a common mission, our conservation model is rooted in the principle of working together to do the best we can for our shared resources.

The broad environmental benefits that wetlands provide society—beyond healthy waterfowl populations—make our mission relevant and critical to the lives of all Canadians. Wetlands represent natural solutions to some of Canada's most pressing environmental concerns including water quality, flooding, endangered species, and climate change.

DUC brings together several efficient, effective approaches to conservation. We deliver on-the-ground habitat projects to conserve and restore wetlands; conduct scientific research that furthers our knowledge about wetlands and the role they play in our lives; lead education efforts that spark a commitment to conservation among the next generation; and carry out policy work designed to inform and encourage governments to protect wetlands.

Looking ahead, DUC has a plan that unites the people, places, and conservation approaches needed for a healthy, prosperous future. By leveraging our science, habitat work, and strong partnerships we strive to create large, landscape-level impact that advances sustainability and climate resiliency.

Culturally, DUC is a diverse group. We come from different backgrounds and walks of life, united by our passion for conservation, the environment, and the outdoors. It's in our nature.

—Larry Kaumeyer, CEO of Ducks Unlimited Canada

Aerial shot of Ducks Unlimited's Coteau Ranch

A pair of mallards balance
on a log over the water.

About Wetlands America Trust

Wetlands America Trust

For more than 65 years, dedicated philanthropists have served wetlands conservation and waterfowl as trustees of Wetlands America Trust. Established in 1955 as the Ducks Unlimited Foundation, WAT changed its name in the early 1990s to reflect its role as the organization's land trust. Today, WAT is one of the country's largest and most respected land trusts.

Wetlands America Trust plays a lead role in support-ing Ducks Unlimited's efforts to guide legislation that im-pacts our conservation and fundraising priorities. Thanks

in part to WAT trustees' relationships with members of Congress, the North American Wetlands Conservation Act has funded more than 3,100 conservation projects across North America. WAT's work in public policy plays an important role in delivering conservation.

WAT trustees are among America's top business lead-ers and actively engage with other corporate, industry, and foundation leaders throughout the country. This outreach is key to our philanthropic success and increas-ing our efforts in natural infrastructure and sustainability.

—Dan Thiel, COO, Wetlands America Trust

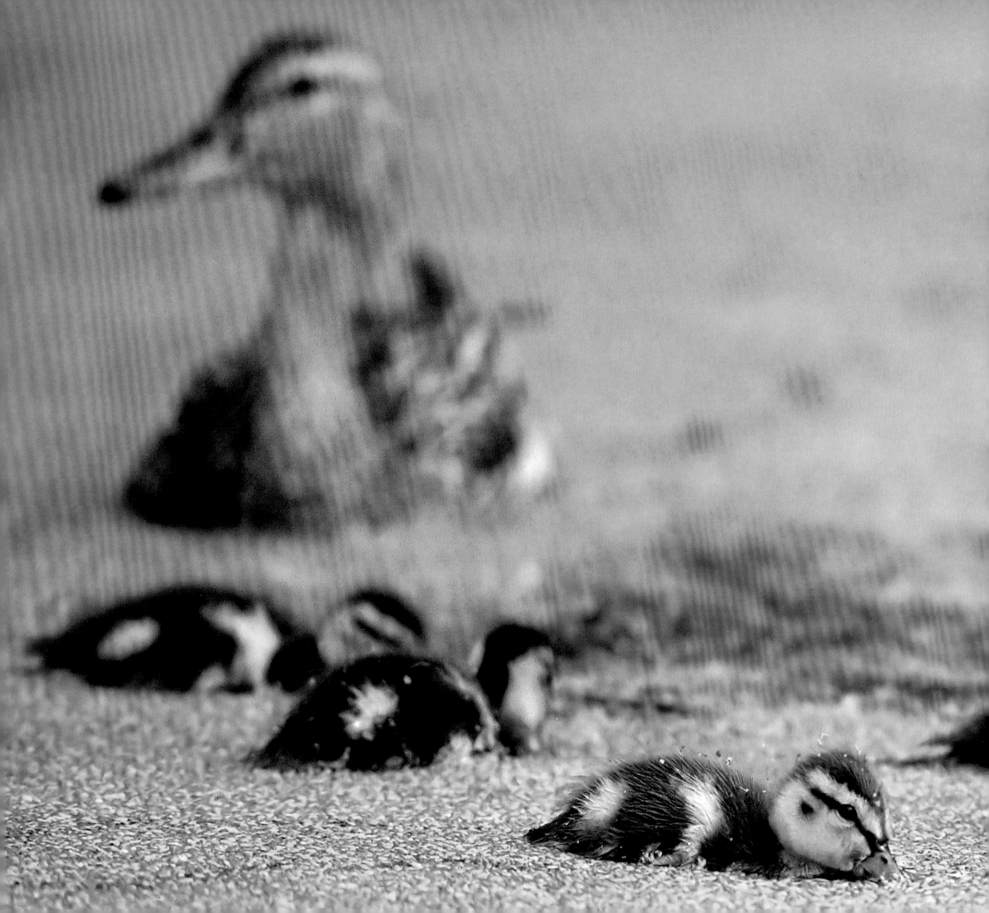

A mallard family floats
through duckweed.

results. According to George W. Bush, former president of the United States, "Ducks Unlimited is the model by which all conservation should be delivered in America."

Those early efforts were supercharged with the 1989 passage of the North American Wetlands Conservation Act, which changed the trajectory of work for ducks, geese, shorebirds, grassland birds, and hundreds of species of common birds that adorn backyards and urban parks all year long. With NAWCA, a financial apparatus was finally in place to support the landscape-scale work required to make sure that sunrises across North America are filled with cupped wings, wigeon whistles, and the braided, lilting choruses of warblers, sparrows, finches, and loons.

There have been many changes, and so many challenges, but one thing has remained constant across the decades: the relationship between prairie ducks and prairie farmers is of paramount importance. In an early edition of the *Ducks Unlimited* quarterly magazine, it was reported that many Canadian farmers "consider ducks as pests because late-maturing field crops are raided by hungry mallards. The hostility of these farmers, which often results in wanton destruction of duck nests, can be alleviated by taking an

A wood duck drifts through
the water.

A green-winged teal perches on a submerged log. Green-winged teals are North America's smallest dabbling ducks.

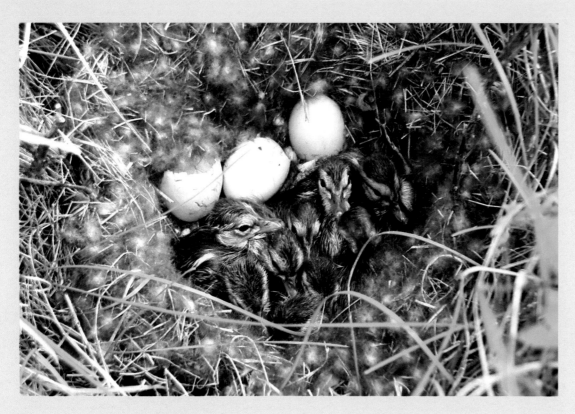
Ducklings huddle in their nest.

interest in the farmers' problems." Such an admonition was pre-scient, and DU stepped up to the challenge.

Across the prairie wetlands today, ducks and geese, wading birds and raptors, songbirds and shorebirds—even moose and bears—all share the land with ranchers and farmers. Across the entire Prairie Pothole Region, 85 percent of the land is privately owned, and the great majority of that is used for row-crop agriculture or raising cattle. Strong relationships with ranchers and farmers are a fundamental part of DU's work in the region. Indeed, without such a symbiotic relationship, the future for waterfowl would be far more imperiled.

"Ranchers and farmers and DU are coming full circle as we understand that we need each other," explains Putnam. "What is good for these ducks—water and grass—is good for cattle, and we're learning more about how to raise crops in ways that support conservation as well. But as conservationists who hunt and farm and raise cattle, we also find ourselves in the position of explaining to society how we all fit together."

Today, most people are generations removed from the land. But those fraying connections need to be stitched back together. New relationships need to be built with those only now learning about the Prairie Pothole Region. Despite decades of conservation success,

the fight to save North America's "duck factory" still faces a great challenge.

This effort is critical because those shallow, glistening wetlands are an ancient, ancestral link that connects us not only to the land under our feet, or paddles, or wader boots, but to a place where water makes possible all of life—and much of what so many outdoors enthusiasts love most in life.

It's possible to restore and conserve the prairie wetlands. Organizations such as DU and the National Audubon Society have shouldered the burden. State and local conservation nonprofits have toiled in the trenches. Partners in government, from municipalities and counties to cities, states, and the federal government, all have invested deeply in the conservation of the prairie wetlands.

And for more than a century, waterfowl hunters have stepped up to the plate. The ducks, geese, swans, and cranes that pour forth from the prairie wetlands might fill the skies over countless numbers of duck blinds, but more importantly, they fuel a special kind of wonder rooted in a desire to work for conservation. Purchases of the Federal Duck Stamp, which is required to hunt waterfowl, have raised more than $1 billion for conservation. Meanwhile, the purchase of state hunting and fishing licenses, tags, and permits

A common goldeneye (*Bucephala clangula*) flies just above the water.

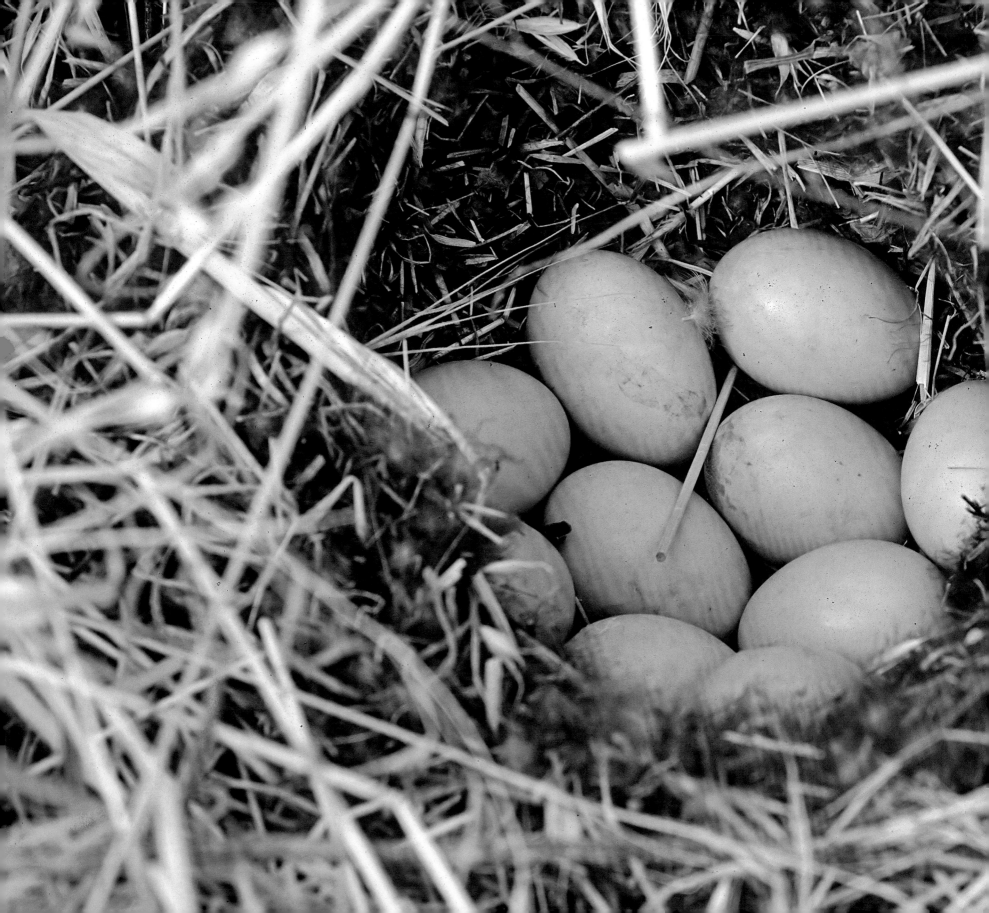

A nest full of eggs
cradled in the grass

returns some $250 million to government wildlife conservation agencies each year, and excise taxes on firearms and most hunting equipment bring in hundreds of millions of dollars for conservation.

Beyond the dollars lies an abiding love of wings and water and the places where they meet. This is precisely why DU is such an ardent supporter of the *Wings Over Water* movie and stands ready to help lead the charge for a movement to conserve the iconic prairie wetlands landscape.

"We see these migratory birds, whether we're hunting or simply enjoying wildlife, and it's an enormous thrill," says George Dunklin Jr., past president of Ducks Unlimited and a current member of Wetlands America Trust, DU's land-trust arm. "I stand in the bottomland hardwoods down here in Arkansas, and it's incredible to think of the adventure these birds go through every year to make the journey, and that they've made the trip for tens of thousands of years."

The *Wings Over Water* team filmed wintering mallards deep in the bottomland hardwoods of Dunklin's Five Oaks Lodge, and the experience underscored the intimate connections between the prairie wetlands and special places far distant. "The Prairie Pothole Region is enormous—300,000 square miles—but so few people live there that it is out of sight and out of mind," Dunklin says. "But every single

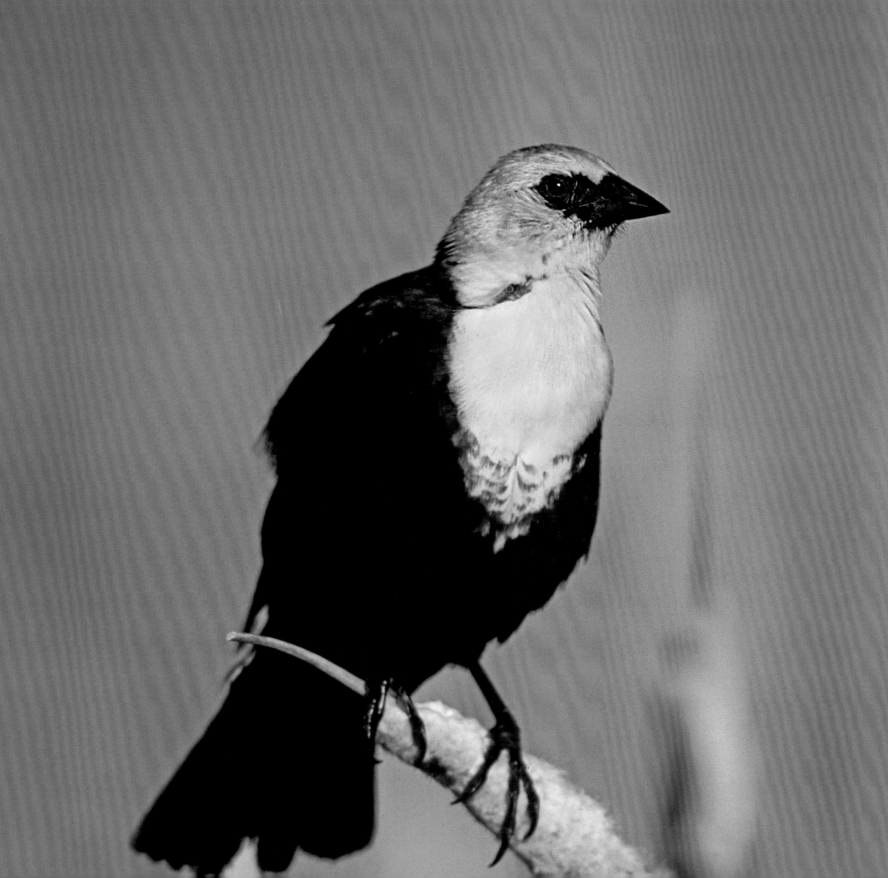

A yellow-headed blackbird (*Xanthocephalus xanthocephalus*) keeps watch. These distinctive birds have a call that's been described as "harsh," "grating," and "mechanical."

person in North America is touched by those prairies and those wetlands and how they work to support clean water and incredible wildlife. This movement to save the prairie potholes is about so much more than birds. It's about that entire prairie pothole ecosystem and all the benefits that come from that landscape. It's about life and the things many of us love most about life."

Even with such passion and commitment, we are losing the prairie potholes. More than half of these vital bodies of water have disappeared since westward expansion reached the plains. Less than 40 percent of native prairie grasslands remain intact. Despite the progress of some of the most forward-thinking conservation initiatives in human history, bird numbers are going the wrong way. According to the Cornell Lab of Ornithology, there are nearly three billion fewer birds in North America today than in 1970.

Until now, there hasn't been a continent-wide campaign to save the prairie wetlands. There has been no captivating movement like the worldwide focus to halt the clear-cutting of the Amazon. Until now, the prairie wetlands have gained no celebrity endorsements. There has been no David Attenborough–esque soundtrack to inspire their conservation.

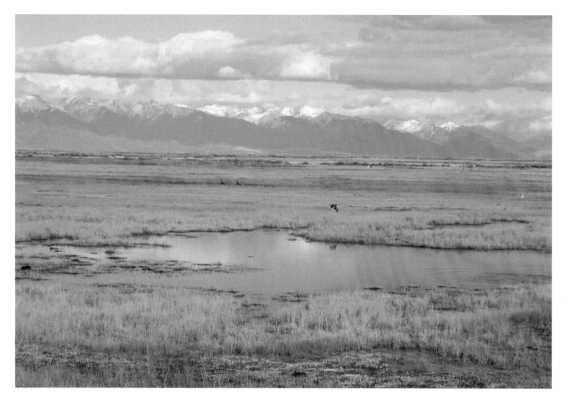

A wetland expanse framed
by mountains

Perhaps this, then, is the moment. The prairie wetlands are a natural treasure on the order of a national park. They are a Yellowstone and an Everglades, a single entity whose impacts touch every coastline, river shore, lake, marsh, and farm pond in America. "*Wings Over Water* could be that seminal moment for the Prairie Pothole Region," Putnam says. "This could be the moment of crisis that gives us a vision of clarity. Very few people who watch this movie will ever visit this incredible prairie pothole landscape. But every single person in Canada, the US, Mexico, and the Caribbean is touched by the incredible life that begins in the prairie wetlands."

We are all connected, and the world is smaller than we realize.

Capturing the magic of *Wings Over Water* required some 300 filming days spread across 30 locations in three countries. Team members drove 25,000 miles of blacktop, gravel roads, and muddy two-tracks. They used every available photographic technology, including ultralight aircraft, remote-controlled cameras, underwater filming, motion control, and high-speed and time-lapse cinematography.

It was all to capture what Ducks Unlimited has spent the last 85 years protecting: birds on the wing headed toward their home waters and the hearts and backyards of everyone on the continent. It's a commitment that every DU volunteer, donor, supporter, and staff member feels in the depths of their soul, which is why Ducks Unlimited welcomes you to *Wings Over Water*. Marvel at the richness of this northern kingdom for wildlife. Then find your own place in the movement to save the stunning prairie wetlands of North America.

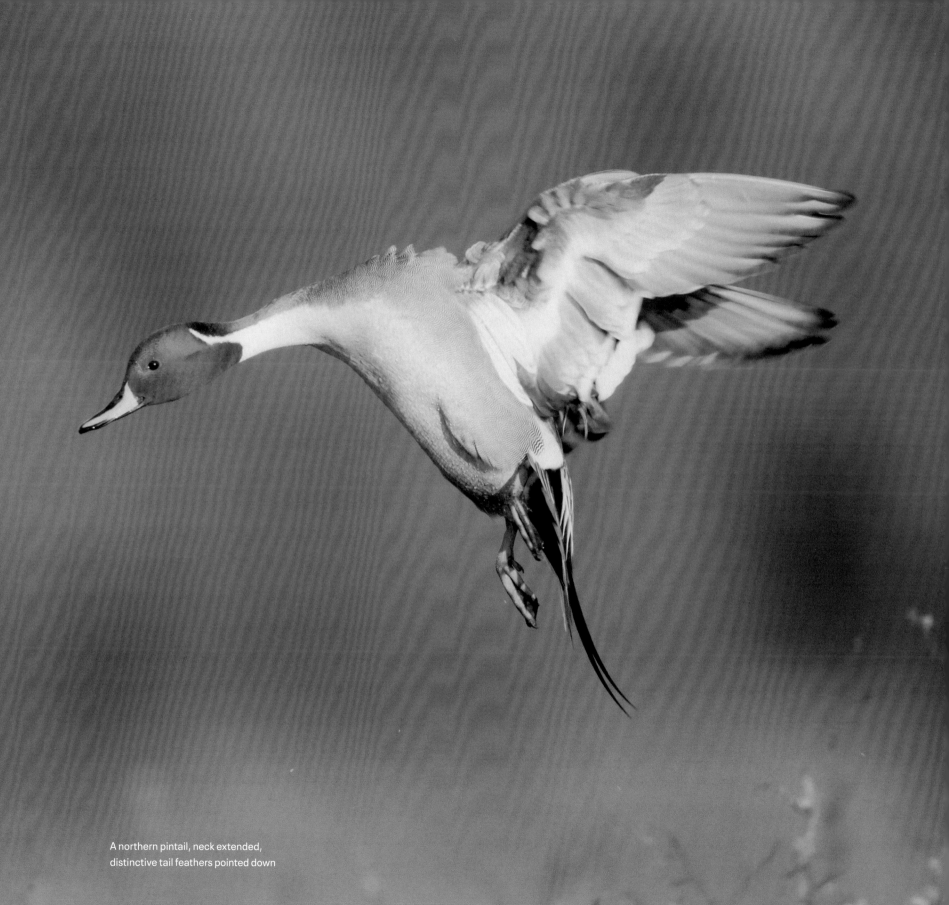

A northern pintail, neck extended,
distinctive tail feathers pointed down

An American wigeon stretches its wings to the front. American wigeons eat aquatic plants but will also graze on plants and seeds found on land.

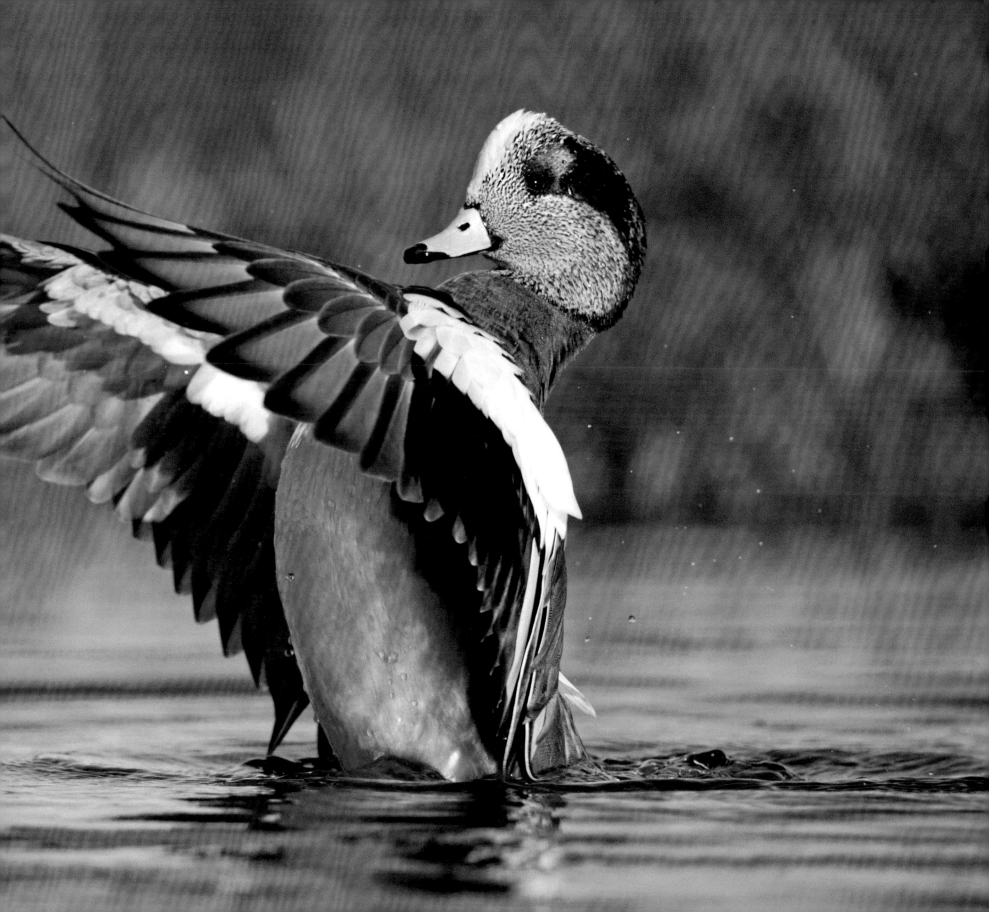

Protecting Birds and Helping Us All

By **Glenn Olson, National Audubon Society**

Glenn Olson is the Donal O'Brien Chair in Bird Conservation & Public Policy for the National Audubon Society. He supports Audubon's efforts to conserve birds and their habitats along the four flyways and internationally, catalyzing work across Audubon's network of state programs, centers, and chapters. He serves as a member of the North American Wetlands Conservation Council and the Neotropical Migratory Bird Conservation Act Advisory Group, both appointments of the US Secretary of the Interior. He previously oversaw Audubon's national field programs and led Audubon California.

M ore than a century ago, the conservation movement that would become the National Audubon Society began with a transcendent goal: to protect the magnificent birds that lived in the nation's wetlands and other key landscapes. Infuriated by the senseless slaughter of egrets and other wading birds solely to decorate women's hats, the conservationist George Bird Grinnell, assisted by Theodore Roosevelt, inspired the campaign with an appeal to readers in his *Forest and Stream* magazine in 1896.

Soon afterward, Harriet Hemenway and Minna B. Hall launched the Massachusetts Audubon Society, and within two years, state-level Audubon Societies had emerged in 14 states and the District of Columbia. Over the following decades, Audubon expanded to become an international coalition of conservationists and the preeminent organization defending birds, while also addressing larger issues that affect all people.

That history and heritage explain why Audubon so eagerly partnered in the production of the IMAX 3D film *Wings Over Water*, an unprecedented effort to call attention to North America's fabulous prairie wetlands and the millions of birds that depend upon them. Those wetlands—cherished by conservationists but little known beyond those circles—are among the most critical habitats for waterfowl and other migratory species, yet they are rapidly shrinking, in part due to the ever-expanding need to grow more food for the world but also because of the inexorable effects of climate change.

We believe that the film's inspirational message, underscored by this companion book, will mark another milestone for conservation and another touchstone in Audubon's century-long crusade to protect our birds and the places where they live.

The driving force of Audubon's grassroots conservation efforts has always been local chapters. But early in the twentieth century, several of those state-level chapters united as the National Association of Audubon Societies, with a focus on the protection of wading birds and colonial waterbirds. They found an eager ally in US president Theodore Roosevelt, who on March 14, 1903, signed an executive order "reserving and setting apart" Pelican Island in

A great egret (*Ardea alba*), feathers spread, leans over a branch.
Egrets were one of the birds at the center of the conservation
movement that resulted in the National Audubon Society.

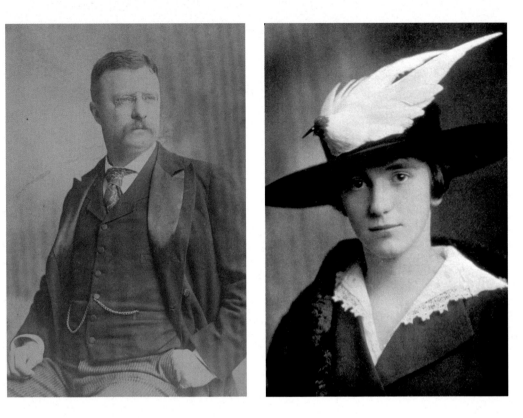

On the left: President Theodore Roosevelt, an early conservationist.

On the right: A woman in a feathered hat. Outrage over the use of bird feathers in ladies' hats was the impetus for founding the National Audubon Society.

Florida "as a preserve and breeding ground for native birds." Few recognized the magnitude of this action, but that day marked the birth of the National Wildlife Refuge system.

During his tenure, Roosevelt created 53 units of the National Wildlife Refuge system in 17 states and territories—17 units in a single day in February 1909, as he prepared to leave the White House. The immense wetlands of Alaska's Yukon Delta, the Malheur region in eastern Oregon, and the Klamath Basin in northeastern California all owe their survival to Roosevelt's vision. In North Dakota, he set aside Stump Lake and Chase Lake as vital staging areas for canvasback ducks and tundra swans. In Louisiana, he created the Breton Island Reservation to help stop the overharvest of waterbirds and their eggs. Now known as the Breton National Wildlife Refuge, it provides essential breeding habitat for coastal nesting birds as well as resting and refueling habitat for songbirds after their epic migrations across the Gulf of Mexico.

Members of the fledgling American conservation movement rejoiced at these developments, but not everyone was pleased. Congress, miffed that Roosevelt bypassed legislative channels to establish the refuges, refused to pay for the wardens needed to protect these sites. The president turned to his friends at Audubon. By the time Roosevelt left office, Audubon had 44 wardens working to protect birds and critical wetland habitats across the United States. They uncovered illegal hunting at Tule and Eagle Lakes that was devastating populations of western grebes and other birds to supply San Francisco markets. The millinery trade remained so lucrative that bird feathers were worth more per ounce than gold. In the southeastern United States, poachers killed three Audubon wardens who were working to protect colonial breeding sites for herons and egrets.

Not all of Audubon's early work involved the refuges. Through the efforts of Audubon and its president, T. Gilbert Pearson, the United States in 1918 ratified the Migratory Bird Treaty Act with Canada. States' rights advocates had fought the treaty until Pearson suggested an amendment to the legislation expanding protection to songbirds. This amendment won the support of farmers and foresters who recognized the birds' value in controlling crop-damaging insects.

Among its many achievements, the treaty ended spring hunting, established seasonal and bag limits on waterfowl, prohibited all shorebird hunting, and above all, began the era of cooperative flyway management of birds that migrate between states and countries. Today, the treaty remains a cornerstone of bird conservation in North America.

An indigo bunting (*Passerina cyanea*) sings on a sunflower.

Soon afterward, Audubon began establishing a network of waterbird sanctuaries and thus initiated the implementation of large-scale, scientifically based bird conservation efforts in North America. Beginning with sites in seven states along the East Coast, the Audubon sanctuary system now comprises dozens of iconic refuges across the country, such as these:

- The Paul J. Rainey Wildlife Sanctuary in Louisiana, one of Audubon's first sanctuaries and an anchor of the Mississippi Flyway, was established in the 1920s. This 26,000-acre wetland with eight miles of frontage on the Gulf of Mexico winters hundreds of thousands of waterfowl and provides habitat for migrating songbirds.

- The Francis Beidler Forest Audubon Center and Sanctuary in South Carolina sustains more than 18,000 acres of wetlands, including the world's largest virgin tupelo and bald cypress forests.

- The Corkscrew Swamp Sanctuary, more than 13,000 acres on the western edge of Florida's Everglades, set out to protect what at the time was North America's largest remaining colony of wood storks, and today it is a critical component of the Everglades ecosystem.

- The Donal C. O'Brien, Jr. Sanctuary and Audubon Center, 2,600 acres of wetlands in coastal North Carolina's fabled Currituck Sound, is a key part of this critical wintering area for the Atlantic Flyway.

- Nebraska's Iain Nicolson Audubon Center at Rowe Sanctuary, protecting 2.5 miles on the Platte River, is a prime rest stop for hundreds of thousands of sandhill cranes fattening up for their journey to their northern breeding grounds.

- The Paul L. Wattis Audubon Sanctuary is a cornerstone of the Sacramento Valley wetlands complex, which provides wintering grounds to upward of 60 percent of the waterfowl in the Pacific Flyway. At times, the sanctuary itself winters 500,000 waterfowl. Each spring, its 28 nesting islands fledge about 3,000 ducks.

Dozens of other Audubon sanctuaries protect native birds and their habitats across America, including colonial nesting waterbirds and migratory songbirds along the Texas coast; provide nesting habitat for ducks and geese on North Dakota's Missouri Coteau; and set aside feeding grounds for canvasback ducks and other seabirds and waterbirds in San Francisco Bay.

Prothonotary warblers (*Protonotaria citrea*) nest in a tree cavity. The warblers' breeding range extends to the southern edges of the prairie wetlands.

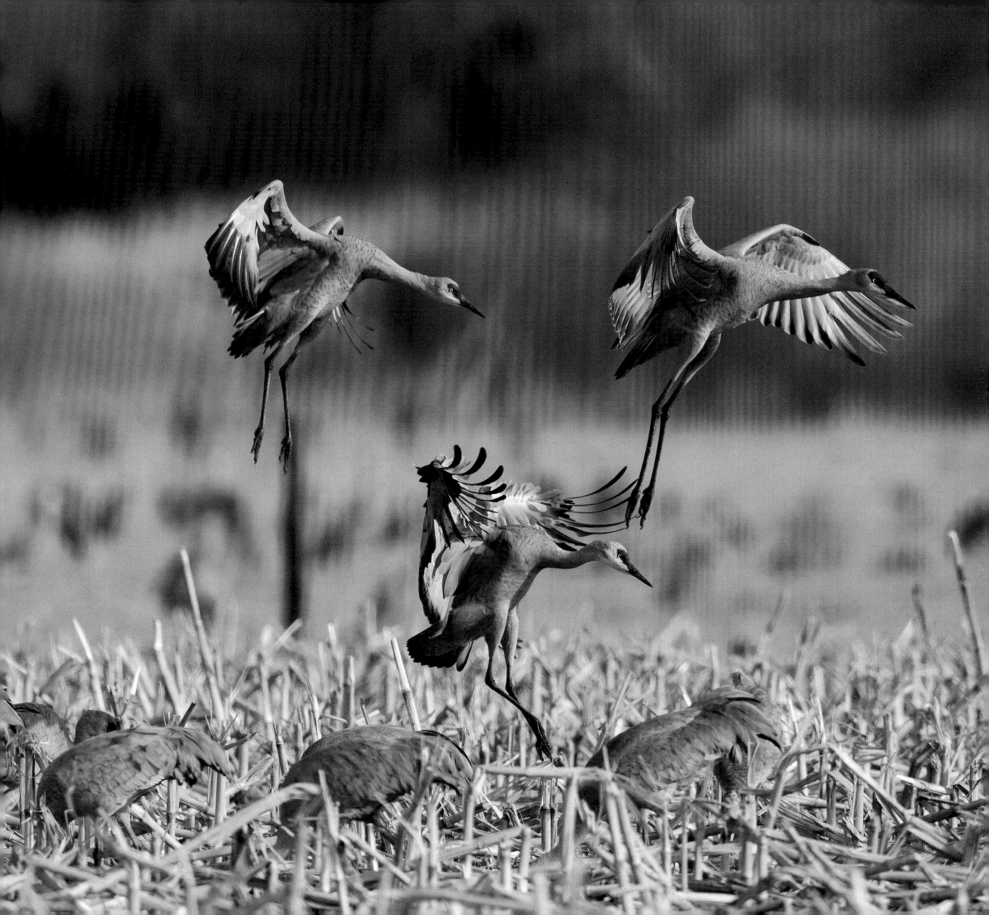

In 1940, the National Association of Audubon Societies became the National Audubon Society, the name our national organization retains today. Audubon later adopted as its symbol the great egret, once a prime target for the plumage hunters who so outraged the society's founders. The National Audubon Society was among the first to warn of the dangers of the pesticide DDT and its role in decimating bird species, including the bald eagle and peregrine falcon. *Audubon* magazine ran excerpts from Rachel Carson's *Silent Spring*.

Audubon's policy work helped establish the Endangered Species Act, the North American Wetlands Conservation Act, and the Neotropical Migratory Bird Conservation Act on the federal level, while helping to catalyze legislative conservation measures in all 50 states. In addition, Audubon led the recovery efforts of many of America's iconic birds, including the peregrine falcon, the bald eagle, the brown pelican, and the California condor.

We continue to call attention to the threats facing birds: in 2019 a report in the journal *Science* estimated a loss of 30 percent of North America's birds since 1970, a net loss of three billion birds. The causes of these declines include habitat loss from agricultural intensification, urban sprawl, and tropical deforestation. Contributing to the declines are human-caused mortality such as bird

Sandhill cranes at the Iain Nicolson
Audubon Center at Rowe Sanctuary

Audubon staff member Nabhí Rodriguez completes data entry after catching a blackpoll warbler.

collisions with buildings and towers during migration, house cats not kept indoors, and feral cats. All of these are exacerbated by climate change. A 2014 Audubon report forecast that 300 species of birds will be threatened or endangered by 2080 because of habitat loss caused by climate change.

To respond to this crisis, Audubon is framing its conservation work going forward around two overriding priorities:

- Migratory Bird Initiative (MBI). This pulls together the best available migration science on species distributions and movements across annual migration routes to identify the highest-priority sites needed to sustain these birds. This information will help focus resources on the most important and threatened sites along the birds' full migratory pathway.

- Audubon Americas. Using the data from the MBI, we are spearheading a collaborative effort to protect the Western Hemisphere's most important areas for migratory birds. Because more than 40 percent of the birds that breed in the US and Canada winter in Latin America and the Caribbean, over the next five years we will target 25 million acres of prime ecosystems critical for both migrants and endemic birds for protection. We will do this in a manner that includes sustaining and improving human well-being in these ecosystems. The second part of Audubon Americas focuses on Canada's boreal forests, one of the most important bird nurseries in North America. Here our strategy is to elevate public support to conserve huge portions of the ecosystem in alliance with the First Nations of northern Canada. These Native Americans are working to create an extraordinary landscape of indigenous protected and conserved areas, and Audubon will provide our expertise in communications and science to support these efforts.

In the United States, our strategic conservation priorities for today and for the future stretch across North America's four flyways and focus on five areas:

- Coasts: We aim to protect marine resources and beach sites for birds and coastal communities, particularly along the Gulf of Mexico, in hopes of increasing the populations of 16 flagship species.

About the National Audubon Society

The National Audubon Society protects birds and the places they need, today and tomorrow, throughout the Americas, using science, advocacy, education, and on-the-ground conservation. Audubon's state programs, nature centers, chapters, and partners have an unparalleled wingspan that reaches millions of people each year to inform, inspire, and unite diverse communities in conservation action. Since 1905, Audubon's vision has been a world in which people and wildlife thrive. Audubon is a nonprofit conservation organization. To learn more, visit audubon.org and find Audubon on social media @audubonsociety.

Audubon

The Rowe Sanctuary in south central Nebraska is owned and managed by the National Audubon Society. At the height of migration season, it can host up to 70,000 cranes per night.

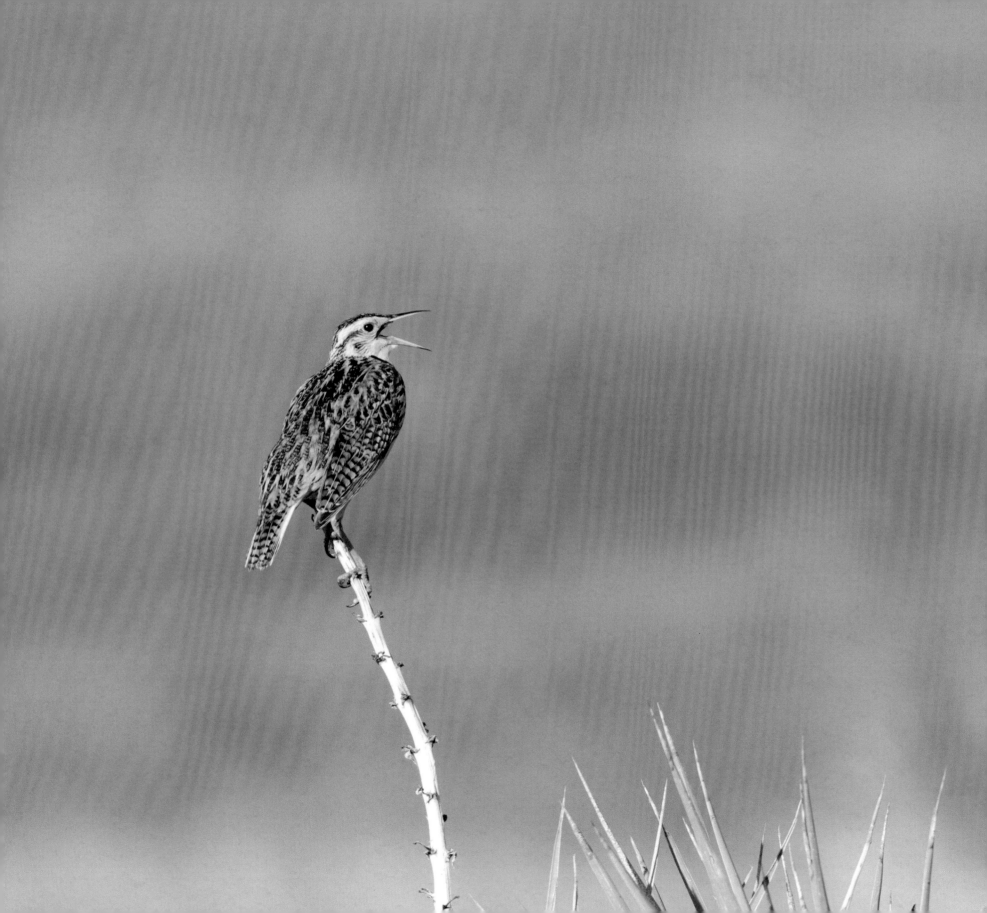

- Working Lands: We collaborate with the owners and managers of private lands to improve and increase habitat on these lands.

- Water: We work on issues involving water rights and quality; restore habitats in wetlands, rivers, and deltas; and seek market-based ways to reach our goals.

- Bird-Friendly Communities: We promote bird conservation efforts in cities and towns, providing food, shelter, and safety for birds and their nestlings. Through individual and collective actions, we promote more sustainable human societies.

- Climate: We leverage people's passion for birds to create demand for action on climate change.

To give one example of these efforts, we have catalyzed a new program working with cattle ranchers called Audubon Conservation Ranching (ACR). Just one percent of North America's native grasslands remain. As a result grassland birds such as the meadowlark, the sharp-tailed grouse, and the long-billed curlew are disappearing. Working with cattle ranchers and guided by sustainable grazing practices, ACR will certify the land these cattle are grazed on as bird-friendly. We already have more than four million acres of private lands enrolled in the program, enhancing habitat for grassland birds.

Audubon's enthusiastic support for *Wings Over Water* is a natural extension of these priorities. The film addresses almost every one and offers unlimited potential to teach millions of people—particularly children—about the magic and mysteries of birds and their habitats, and the need to protect and sustain them forever.

Audubon today is working to diversify our network to become more like the face of America in the twenty-first century. Audubon now includes 23 state offices and 33 Audubon Centers, half of which are in underserved communities where nature may not be easily accessible. We need these communities in our network as we

A western meadowlark (*Sturnella neglecta*) calls from its perch. Western meadowlarks prefer grasslands and commonly use the northern US prairie wetlands as their breeding grounds.

Sandhill cranes circle
the water at sunset.

seek to build awareness of conservation and appreciation of nature with voters and citizens across the land. We have a network of 452 chapters in local communities across the United States. We're on scores of college campuses, working with the next generations of conservation leaders, and our members—nearly two million—are dedicated to a better world, not just for birds but for people.

By bringing bird and wetlands conservation to the giant screen and into the classroom, we believe that *Wings Over Water* can inform and inspire entire swathes of our society, including those who have not traditionally been a part of the conservation movement. This is a thrilling prospect, for conservation is not partisan nor the province of any single group. The mission of protecting our ecosystem is one that benefits us all, and therefore, our movement must be open and welcoming to all. *Wings Over Water* is an open invitation to join Audubon, our partners, and others in working to protect birds and our environment—an invitation we hope millions will accept.

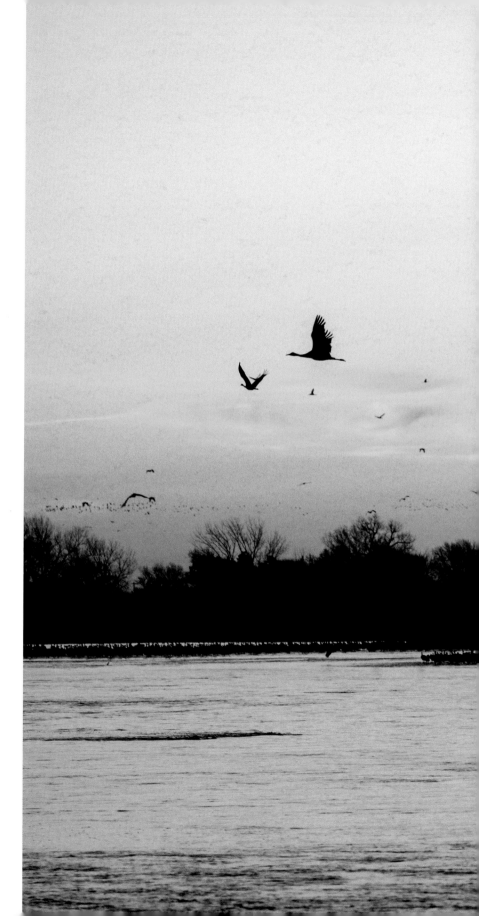

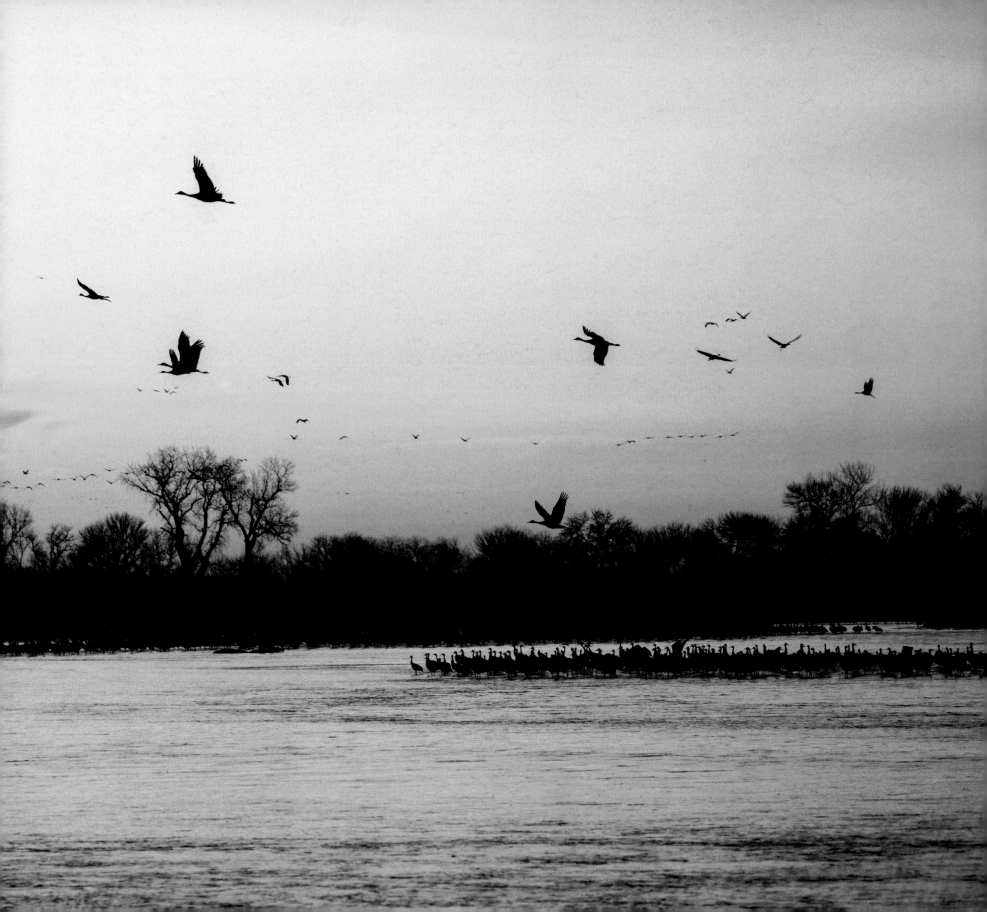

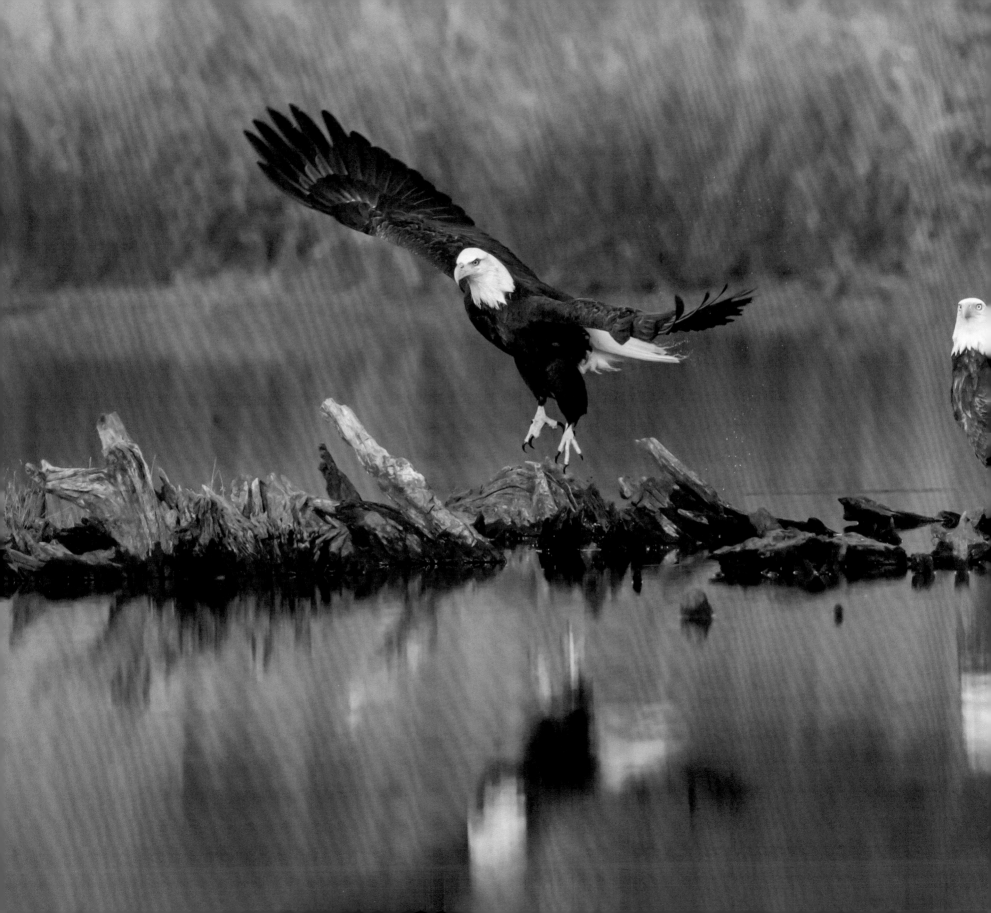

Two bald eagles (*Haliaeetus leucocephalus*) perch over the water. Bald eagles can be found in various regions of the prairie wetlands throughout the year. Though eagles are predators themselves, at times great horned owls or other animals will invade eagle nests.

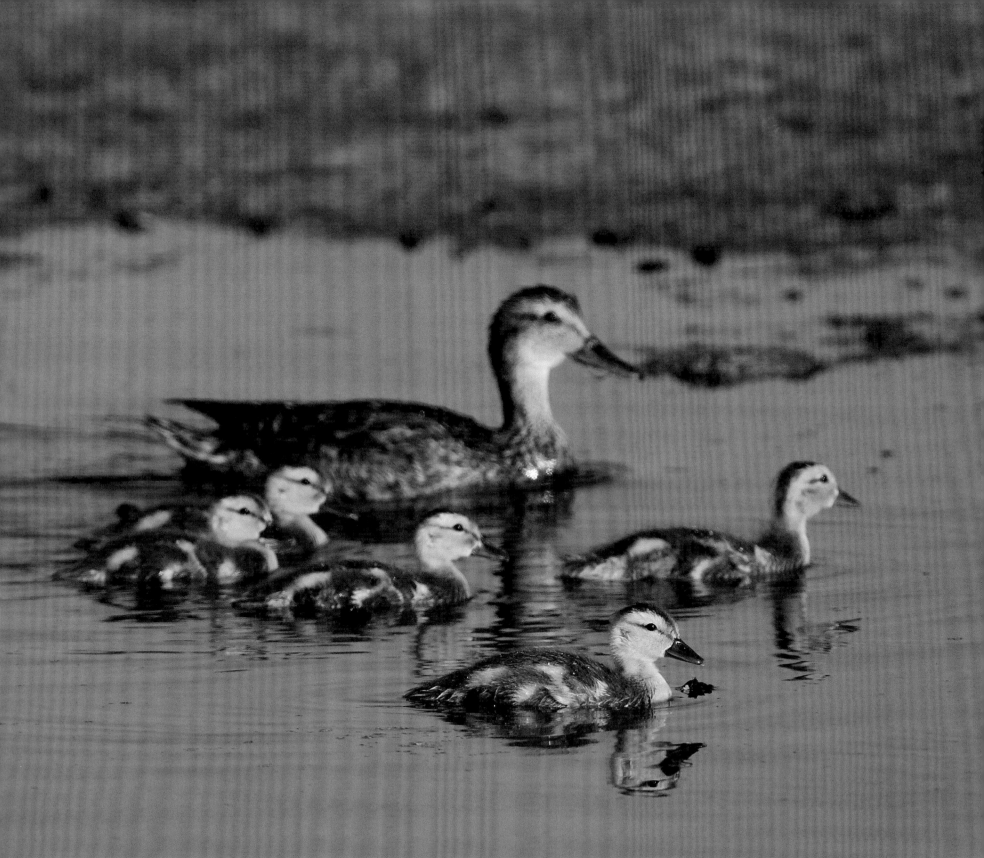

Gadwall family on the water

Scientific Advisers

DR. GEORGE ARCHIBALD
Cofounder and senior conservationist,
International Crane Foundation

DR. ANDREW FARNSWORTH
Senior research associate, Information
Science, Cornell Lab of Ornithology

DR. STANLEY GEHRT
Director of the McGraw Center for Wildlife
Research/professor, The Ohio State
University

DR. MELANIE GUIGUENO
Assistant professor, McGill University

DR. DAVID HOWERTER
Chief conservation officer,
Ducks Unlimited Canada

MARSHALL JOHNSON
Interim chief conservation officer,
National Audubon Society

ANNE LACY
Research coordinator,
International Crane Foundation

MIKE AND ALI LUBBOCK
Executive director and assistant director,
founders, Sylvan Heights Bird Park and
Avian Breeding Center

DR. PETER MARRA
Emeritus senior scientist,
Smithsonian Migratory Bird Center

DR. TOM MOORMAN
Chief scientist, Ducks Unlimited

DR. DAVID MUSHET
Research wildlife biologist,
Northern Prairie Wildlife Research Center

DR. FRITZ REID
Director of Boreal and Arctic Conservation,
Ducks Unlimited

DR. FRANK ROHWER
President and chief scientist,
Delta Waterfowl Foundation

Many pollinators, such as bees, wasps, bats, and butterflies like the monarch (*Danaus plexippus*) pictured here, rely on the variety of flowering plants found on the grasslands of the prairie.

Birds aren't the only animals that rely on the prairies. The North American prairies are home to a number of mammals, reptiles, fish, and insects. American badgers (*Taxidea taxus*) are native to the prairies of the Great Plains.

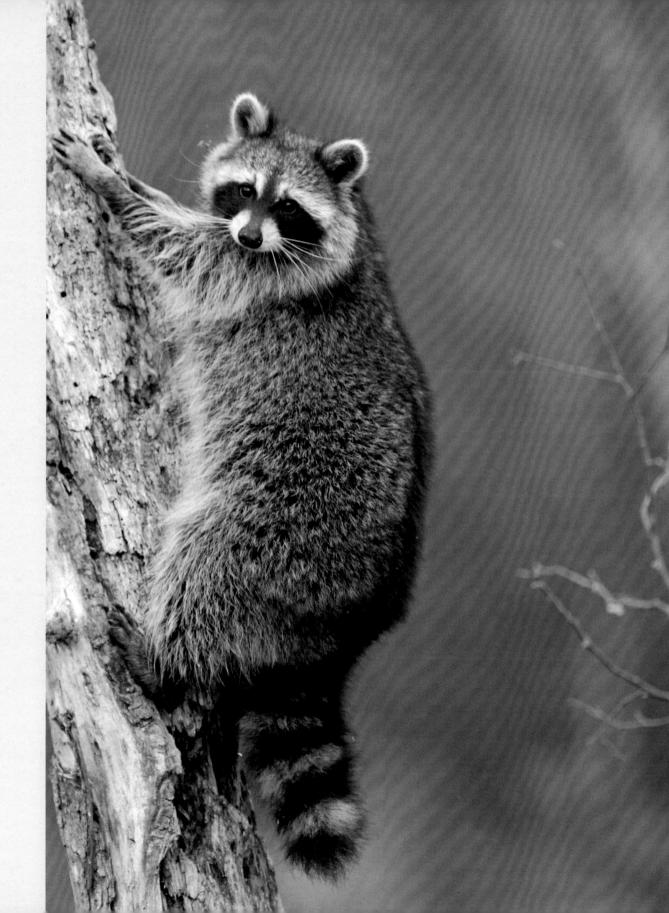

On the left: Another prairie native, the coyote (*Canis latrans*), prepares to leap.

On the right: While North American raccoons (*Procyon lotor*) like the one on the right can thrive in urban areas, their natural habitats are grasslands and forests.

Common snapping turtles (*Chelydra serpentina*) live in fresh water and spend most of their time in the water rather than on the land.

A pair of ruddy ducks (*Oxyura jamaicensis*) swim through the water. Ruddy ducks have stiff tail feathers that they often hold upright, and breeding males have blue bills.

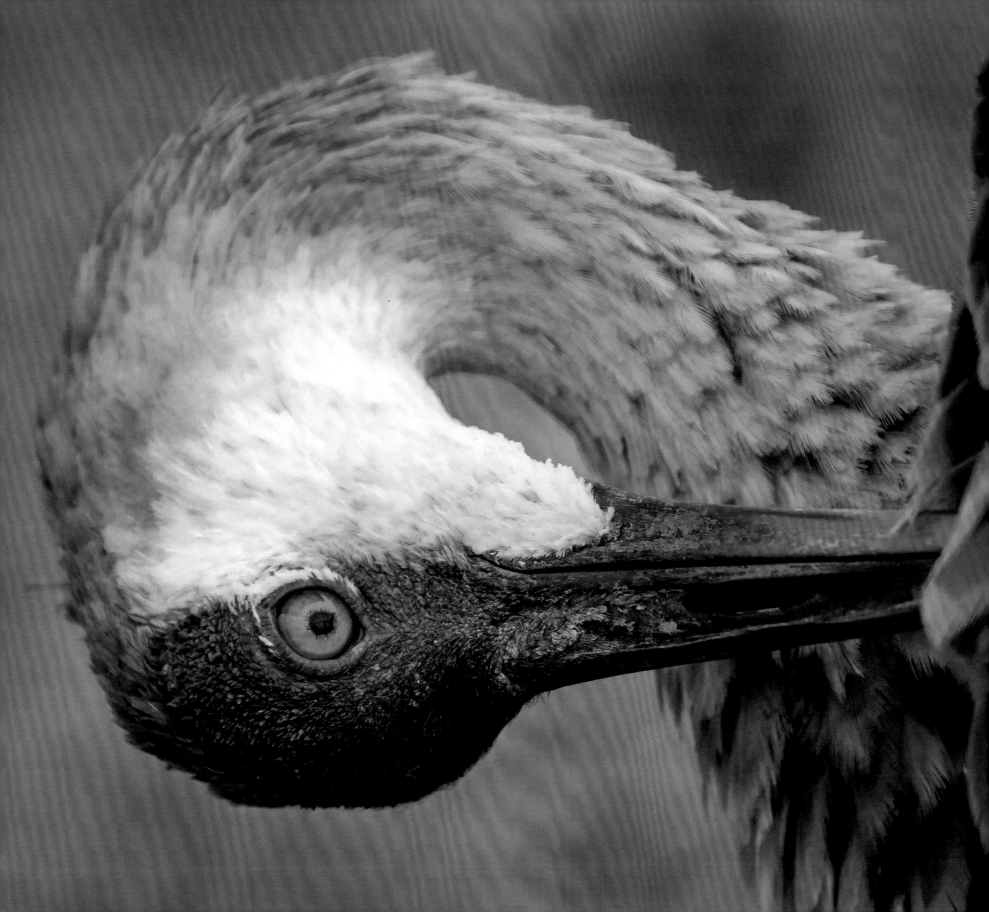

Photo Credits

Principal photography by Gary Kramer.

Gary Kramer is an outdoor writer and photographer based in Willows, California. He is one of the nation's most active outdoor writers/photographers and has published more waterfowl photos than anyone in the world. He holds bachelor and master of science degrees in wildlife biology and for 26 years was a wildlife biologist and refuge manager with the US Fish and Wildlife Service. Gary retired from the Service to pursue a full-time writing and photography career.

Index

About the Filmmaking Team

Dorsey Pictures

Dorsey Pictures, a Red Arrow Studios Company, is a Realscreen Global 100 television production company that has created more than 100 television series across numerous genres for broadcast, cable, and streaming distribution worldwide. Chris Dorsey served as executive producer of *Wings Over Water* and is a leader in employing communications strategies that impact public policy. He's served on the boards of numerous conservation organizations and is a sought-after speaker and consultant on the topic of media and conservation policy.

Archipelago Films

Wings Over Water is produced by Academy Award–nominated and Emmy Award–winning Archipelago Films, and directed by Andrew Young of Archipelago Films. The Archipelago team of Andrew Young and Susan Todd were behind *Backyard Wilderness 3D*, which received 14 awards, including the top industry awards from the Giant Screen Cinema Association.

SK Films

For almost 25 years, SK Films has had a reputation as one of the most accomplished and respected distribution and production companies in the IMAX/giant screen industry. Founded in 1998 by Jonathan Barker in partnership with IMAX cofounder Robert Kerr, SK is now led by esteemed industry veteran and CEO Wendy MacKeigan. Wendy is also an accomplished screenwriter, and she cowrote *Wings Over Water 3D*.

Previous projects by SK Films include some of the most successful and acclaimed films in the medium in the past 20 years: the Oscar short-listed *Bugs! 3D*, the acclaimed *Flight of the Butterflies 3D*, *Amazon Adventure 3D*, and *Backyard Wilderness 3D*. All four were highly recognized, and *Flight of the Butterflies* is the only IMAX/giant screen film to ever receive a clean sweep of all industry awards.

SK's current projects include BBC Earth's *Antarctica 3D*, narrated by Academy Award nominee Benedict Cumberbatch, and SK is the worldwide distributor for *Wings Over Water 3D*. Visit our website at skfilms.ca.

Diane Roberts—Supervising Producer

Diane began her film career in the UK in feature films, documentaries, commercials, and music videos.

Her IMAX career began with *Rolling Stones Live at the MAX*, the first IMAX concert film.

Diane joined the IMAX Natural History Unit in Bristol, working with Christopher Parsons OBE, and produced the Academy Award–nominated *Fires of Kuwait*, followed by *The Secret of Life on Earth* and *Survival Island*.

She has a distinguished career and continues to be involved in the production of many IMAX films, including *All Access*, *Wolves*, *Straight Up*, *Journey to Mecca*, *Born to Be Wild*, *Island of Lemurs: Madagascar*, Terrence Malick's *Voyage of Time: The IMAX Experience*, *Pandas 3D*, *Superpower Dogs*, *The Great Bear Rainforest*, *Asteroid Hunters*, and *Wings Over Water*.